EDWARD BURNE-JONES

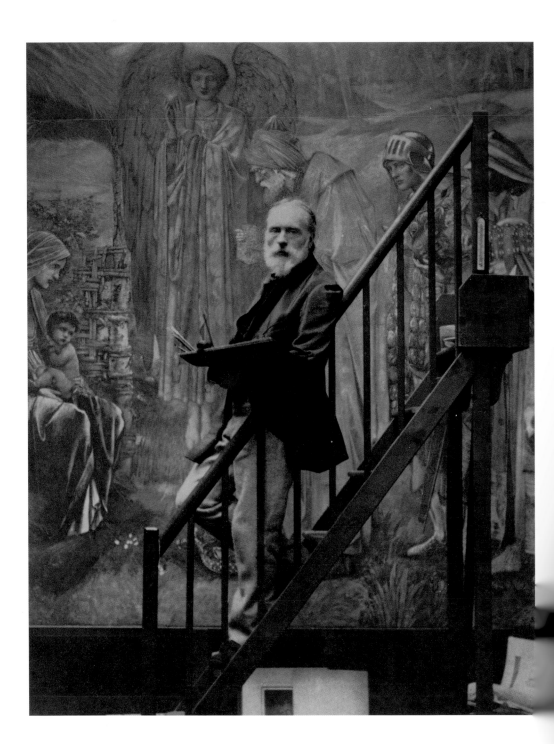

EDWARD BURNE-JONES

David Peters Corbett

British Artists

Tate Publishing

Acknowledgements

I am grateful to the many curators and librarians who have helped me during the writing of this book, particularly those at the University of York, the University Library, Cambridge, the Fitzwilliam Museum, Cambridge, the British Library and the London Library. I was fortunate enough to be a Visiting Fellow at Clare Hall, Cambridge, while I was working on the book and was able to enjoy a congenial and supportive academic environment at a crucial stage of the research. It is inevitably the case that a book such as this must rely on existing work in the field. I wish to record my debt accordingly to Stephen Wildman and John Christian, whose catalogue, *Edward Burne-Jones: Victorian Artist-Dreamer*, for the 1998–9 exhibition in New York, Paris and Birmingham has proved an indispensable guide and reference, and to Penelope Fitzgerald, whose sensitive biography of the artist has often proved illuminating. Finally, Nicola Bion has been a supportive and inspirational editor throughout, and Dick Humphreys has been an encouraging General Editor. Both have been patient.

First published 2004 by order of
the Tate Trustees
by Tate Publishing, a division of
Tate Enterprises Ltd,
Millbank, London SW1P 4RG
www.tate.org.uk

© Tate 2004

British Library Cataloguing in Publication Data
A catalogue record for this book is available from the British Library

ISBN 1 85437 435 4

Distributed in North America by Harry N. Abrams Inc., New York
Library of Congress Control Number: 2004102568
Concept design James Shurmer
Book design Caroline Johnston
Printed in Hong Kong by South Sea International Press Ltd
Front cover: *Sidonia von Bork* 1860 (fig.13, detail)
Back cover: *The Golden Stair* 1876–80 (fig.23, detail)
Frontispiece: Burne-Jones working on *The Star of Bethlehem*, 27 July 1890, photographed by Barbara Leighton, National Portrait Gallery, London
Measurements of artworks are given in centimetres, height before width and depth, followed by inches in brackets

CONTENTS

INTRODUCTION

Edward Coley Burne-Jones, or plain Ted or Ned Jones as he was known for a long time, was born in Birmingham on 28 August 1833 at 11 Bennett's Hill, the business premises of his father who worked there as a frame-maker, carver and gilder. As Sir Edward Coley Burne-Jones he became one of the most successful and honoured of late Victorian painters, one whose art defined for both his contemporaries and posterity the 'dream world' of late nineteenth-century Aestheticism and the role of art as an alternative to the vulgar and disturbing world of the everyday. 'It is the art of culture,' wrote Henry James of Burne-Jones's painting, 'of reflection, of intellectual luxury, of aesthetic refinement, of people who look at the world and at life not directly, as it were, and in all its accidental reality, but in the reflection and ornamental portrait of it furnished by art itself.'[1] Burne-Jones himself demanded on occasions that all his viewers should 'pass through the golden gate of his dreams' or spoke in terms which seem to imply escapist aims.[2] One of his dealers, Comyns Carr, took it for granted in his introductory essay to the 1898 retrospective held at the New Gallery in London, that 'the beauty he presents has been formed to inhabit a world of its own, remote from our actual world'.[3] Most viewers of Burne-Jones's works have felt something like this, and the art historian Debra Mancoff is typical of modern commentators in agreeing with Carr: 'every picture Burne-Jones painted', she writes, 'took him on a journey through the land of his dreams'.[4]

The intensity and authority of Burne-Jones's vision of this alternative world gives it a powerfully individual quality which seems unrepeatable, as his many imitators found: 'here was an artist to whom the stereotyped expressions of disapproval or endorsement could not be applied', wrote Malcolm Bell of Burne-Jones's triumphant appearance at the first exhibition of the Aestheticist 'palace of art', the Grosvenor Gallery in New Bond Street, where his reputation was confirmed.[5] And the uniqueness of Burne-Jones's achievement secured him, from at least that moment on, an unassailable place in the pantheon of British painters.

Burne-Jones's art is immediately recognisable. His series of paintings entitled *The Days of Creation*, made between 1870 and 1876, were exhibited in 1877 at the first show at the Grosvenor Gallery and have some claim to be properly representative of his strongest and most characteristic period (figs.2 and 3). The subject builds a fantasy of angelic faces and bodies clothed in sumptuous garments out of the creation narrative in Genesis: each of these seven epicene and abstracted figures, as they come on stage with the passing days, is given a globe to hold in which the process of creation is played out, from the seas and land emerging out of the swirling darkness upon the face of the earth to the appearance of Adam and Eve. The subject of creation, the conjuring of substance out of the void, is embodied also in the elaboration and

1 George Frederic Watts
*Portrait of Sir Edward
Burne-Jones, Bt.* 1870
Oil on canvas
64.8 × 52.1 (25½ × 20½)
Birmingham Museums &
Art Gallery

detail of the way Burne-Jones's paint describes these scenes. The paintings use the rich textures generated by combining different media – gouache, shell gold and platinum paint – to create a scintillating surface that marries precision, in its description of fabric, flesh and angels' wings, with an extreme assertion of the capacity of these media themselves to attract and seduce the spectator's eye. Burne-Jones's works often perform this double process, on the one hand the detailed and evocative description of an imaginary world, and on the other the concrete realisation of imagination itself in the form of pigment, colour and line.

Something similar could be said of many artists, but in the case of Burne-Jones the recurrence and continuity of this double axis, both throughout his career and as a major theme in some of his most important works, gives it a particular saliency in understanding his art. His is a painting of exceptional self-reflexivity: the works continually circle round upon themselves, returning to question repeatedly the grounds of their own constitution and their own claims to value and meaning. Built out of substance, materiality, the shimmering glitter of rare or fine media like gold or pearl, or the dense and impacted paint surfaces which Burne-Jones created over many works, his paintings dwell on the capacity of these physical substances to describe some portion of reality. But they also often worry about how real that capacity is. They deal in this way with issues that are important for all painters and for anyone interested in understanding how painting works and what it can mean for us; how, that is, it can serve our understanding of the world. This is not an art which ignores reality by cleaving to its dream, but one that concerns itself with the ways in which art, and specifically painting, can hope to engage meaningfully with reality.

The unusual, literally extraordinary, quality of Burne-Jones's art is the product not only of this focus on the act and power of creation, but also of an unfamiliar cast of mind for a painter: for Burne-Jones imagined his art as meaningful in ways that are not just the products of the impact of colour, line and form. 'He saw nothing from the purely pictorial point of view', reminisced W. Graham Robertson, who knew Burne-Jones for many years:

> Albert Moore would come in from a walk full of almost inarticulate delight at the memory of black winter trees fringing the jade-green Serpentine, or of a couple of open oysters lying on a bit of blue paper or of a flower-girl's basket of primroses seen through grey mist on a rainy morning. Burne-Jones would have woven a romance or told an amusing tale about the flower girl, but would not have noticed her primroses, the combination of the silvery oysters and the blue paper would not for a moment have stuck him as beautiful; he had not the painter's eye.[6]

Largely self-educated as a painter – a process that went on, and in fact reached its apogee after he had become established and well-known – Burne-Jones's technique was always eccentric and frequently provoked comment from his contemporaries. Robertson seems to attribute this peculiarity to a fundamental orientation away from the visual arts. His is a tempting

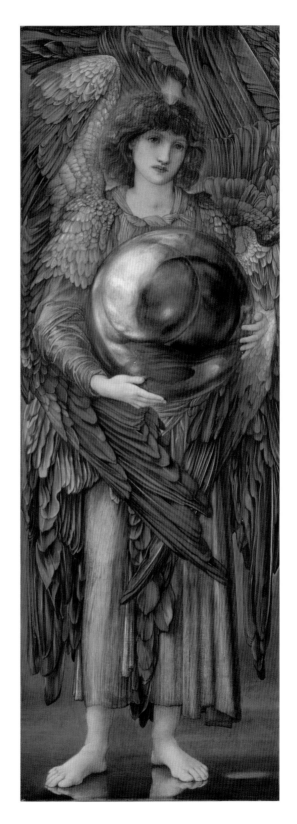

2 *The Days of Creation: The First Day* 1870–6 Watercolour, gouache, shell gold and platinum paint on linen-covered panel prepared with zinc white ground 102.2 × 35.5 (40¼ × 14) Fogg Art Museum, Harvard University Art Museums, Bequest of Grenville L. Winthrop

interpretation, both because it is true that Burne-Jones's first public works were literary and because he subsequently refused opportunities to write or talk with a fervour that suggests some significant repression. But it is also true that as a schoolboy he was 'always drawing': from the age of 15 he attended the Government School of Design in Birmingham alongside his school studies.[7] However unusual the art that he produced in the scale and technical realisation of its ambitions, Burne-Jones was dedicated to the potential of the visual from an early stage in his life and throughout his career.

Whatever his talk of 'dreamland', Burne-Jones in fact also conceived of his art from the first as meaningful and important in the world. As a schoolboy he, like many of his peers at King Edward's Free School in Birmingham, which he attended from the age of 12, was, he said, quite awake to 'the crying evils of the period'.[8] The world he saw around him from the slightly precarious perspective of his father's grip on the Birmingham middle classes was the world of Victorian industrialisation with its factories, wretched labouring class, and the endless, energetic hum of its machinery. This was the period when Britain was the 'workshop of the world', and when the driving forces of capitalism remade landscapes and towns in a new image, with mills, factories and machines, and the labouring classes who serviced them turning the great manufacturing cities, of which Birmingham was one, into what many contemporaries thought of as deserts of modernity. The human costs, as well as those to the environment, were very evident to the young Ned Jones. 'I remember one Saturday night', he later recalled, 'walking five miles into the Black Country, and in the last three miles I counted more than thirty lying dead drunk on the ground, more than half of them women.'[9]

Contemporary commentators who later identified the dream work of Burne-Jones's art also understood that this did not bar it from contemporary relevance. Julia Cartwright, writing on Burne-Jones's 'life and work' for the *Art Annual* in 1894, began with the statement that 'the art of Burne-Jones from first to last has been a silent and unconscious protest against the most striking tendencies of the modern world'. She was quite clear what these tendencies were and what the virtues were of setting art against them:

> In an age when the scientific spirit has penetrated into every
> department of life ... this master, almost alone among his peers, has
> revealed an imaginative faculty of the rarest description. In a period
> which is essentially prosaic, when realism has invaded both art and
> fiction, and material prosperity seems to be the end and aim of all
> endeavour, he has remained a poet and an idealist ... From the
> dullness and ugliness of the present he turns with all the passionate
> ardour of his being to the forgotten past, and there, in the myths and
> fairy-tales of the old world, he finds the food after which his soul
> hungers. There his love of beauty is satisfied, his imagination finds
> itself at home.[10]

Cartwright directly connects the alternative values she finds in art with a rejection of the dominant values of British culture at the end of the nineteenth century. Art provided the sustenance which life under Victorian

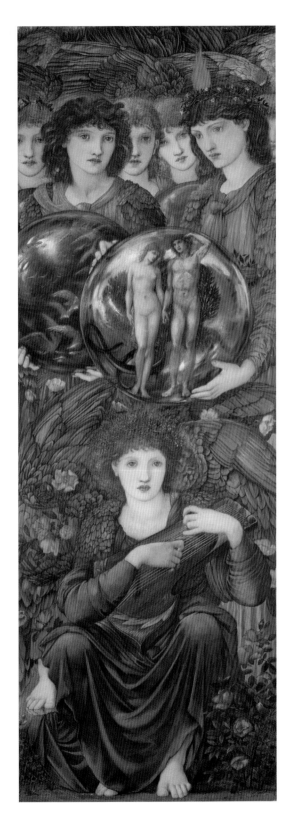

3 *The Days of
Creation: The Sixth
Day* 1870–6
Watercolour,
gouache, shell gold
and platinum paint
on linen-covered
panel prepared with
zinc white ground
102.2 × 35.5
(40¼ × 14)
Fogg Art Museum,
Harvard University
Art Museums,
Bequest of Grenville
L. Winthrop

materialism failed to offer: its necessary nourishment was spiritual, defined as those uncommercial currents of the human soul which appear to lack all use value in economic terms: 'idealism', 'invention', and 'imagination'. Writing in 1908 the art critic J.E. Phythian offered his own version of this justification in a book on Burne-Jones, arguing that 'all stories told or written have arisen out of life's experience', but that 'the truest, in the deepest sense of the word, are not always those that merely recite facts'.[11] It was the important French critic Robert de la Sizeranne who, in his book, *Contemporary English Art* (1898), provided the best exposition of this viewpoint:

> It is perfectly true that [Burne-Jones] does not paint dresses from Worth, or furniture from the stores. He should be congratulated thereupon. But it is an immense error, made by realists in search of modern superficiality, to think that his works suggest fewer contemporary pictures, fewer existing interests, because they are further apart from our daily life than the illustrations of the *Graphic* and the *Illustrated London News*. This is proved by the permanent impression they leave on anyone who has seen them. For myself, I never looked at some of his works without a revival of the anxieties and realities of the passing hour.

Sizeranne goes on to discuss Burne-Jones's *Love Among the Ruins* of 1894 (fig.4) as an example of this effect, concluding that 'our thoughts were with the present, with the ruins amidst which we live, which are all too real', and linking the painting's subject directly to an account of late nineteenth-century despair at the dismantling of certainties which modern life had effected.[12] For commentators like Sizeranne and Cartwright, Burne-Jones's devotion to the unreality of his fictional worlds allows him a vantage point from which the truths of contemporary experience can be rendered visible. The dream-work of his art is a tool through which 'the natural reaction from an age of rationalism and materialism' can offer consolation, but also diagnosis and critique.[13]

These issues of industrialisation and materialism were already receiving thoughtful public expression by the time Burne-Jones began to encounter them during his Black Country wanderings as a schoolboy. The great Victorian thinkers, Thomas Carlyle, John Ruskin, John Henry Newman and others, were denouncing the materialism and moral ugliness of the modern world which industrial capital had made, and were positing their own alternatives. In particular Burne-Jones's imagination and early yearnings towards moral renovation, purity and spiritual values were captured by the ideas of the Tractarian movement. Inaugurated at Oxford by Newman, the movement attempted a renewal of the Anglican Church, delving back into the Catholic past for inspiration and placing a strong emphasis on the spiritual benefits of ritual and richness in clothing, decoration and display, all the visual appurtances of the Church. It dealt, as well, with the importance of spiritual values which seemed to Burne-Jones and many of his contemporaries to have been omitted or erased from modern life: 'in an age of sofas and cushions', wrote Burne-Jones of Newman, 'he taught me to be indifferent to comfort; and in an

4 *Love Among the Ruins* 1894
Oil on canvas
96.5 × 160 (38 × 63)
The Bearsted
Collection,
Wightwick Manor
(The National Trust)

age of materialism he taught me to venture all on the unseen'.[14] Tractarianism gave Burne-Jones his first route to expression for his dissatisfaction with the modern world. It encouraged him to develop a romantic, spiritualised medievalism, which he conceived as an alternative to the brutalities of contemporary life. At the same time, Birmingham provided examples of the medievalising architecture of the Catholic convert A.W.N. Pugin (1812–52), which sought to give a form to such counter-modern feelings and beliefs. Compassion, love, contemplation and a meditative understanding of our individual encounter with the world were all aspects of the human experience that Burne-Jones sought in his engagement with the medieval past and the modern present. It was this committed, intense, and above all spiritualised recovery of the past as the embodiment of human good in opposition to a corrupted and mechanistic present that Burne-Jones was eager to discover when, in 1853, he went from Birmingham to Exeter College, Oxford, with the firm intention of becoming a priest.

1

THE NICEST YOUNG FELLOW IN DREAMLAND

The Oxford that Burne-Jones encountered as an undergraduate at Exeter College was not the vital seedbed of new ideas that Tractarianism had made it in his imagination. The movement had run itself out in its place of origin and there had been a widespread return to other, perhaps less demanding, forms of religious observance and practice. Burne-Jones's depression at this discovery seems to have been profound and it gave him common cause with William Morris, another new undergraduate at Exeter who was also hoping to go into the Church and now found himself equally out of countenance as a result of the reality of the Oxford they had found. The two spent their time in 'gloomy disappointment and disillusion', and in 'angry walks' through the streets of the town.[1]

This situation seems to have induced something very like a crisis in Burne-Jones, who at one time seriously contemplated a commission in the Crimean War and at another, with equal seriousness, planned to found a monastery, before turning to the more viable route offered by contemporary alternatives to the Tractarian movement. Most notably he and Morris read Thomas Carlyle and John Ruskin, two of the most imposing of the Victorian 'vates' – visionary thinkers whose diagnoses of contemporary life and experience embraced the whole of their culture, and who propounded vigorously argued and pungently expressed alternatives to capital and the machine. Carlyle and Ruskin gave the young Burne-Jones a secular, although not irreligious, version of the morality he had sought in Tractarianism. They saw the artist or writer as a 'hero', to use Carlyle's concept, a priestly mediator of experience and reality to the citizens of the modern world, who could interpret for them experience that was often threatening and puzzling. This sternly moralistic and in many ways puritanical ethic of duty granted the artist, as Burne-Jones and many other Victorians understood that role, both an obligation and a power to assuage the depredations of modernity. The true values of human experience were made vivid and brought forth for their audiences. The artist's imaginative creation was a medium leading straight to the heart of reality, casting aside the surface fripperies of the world.

This view of the artist's role remained with Burne-Jones throughout his life. 'Up till now', he wrote later, 'I seem not to have done anybody any good, but when I work hard and paint visions and dreams and symbols for the understanding of people, I shall hold my head up better.'[2] Painting for the illumination of his audience, the transformation of the phantasmagoria of 'real life' into the true spiritual realities and values which lay behind it, became his

purpose and ambition for the rest of his career. Ruskin had associated the spiritual values accessed by the artist with truth to nature, and Burne-Jones now set out to teach himself some painting, copying the detailed appearances of nature as Ruskin recommended, in the fields and meadows around Oxford. At this critical moment in his development Burne-Jones encountered for the first time the work of a group of artists and writers whose ambitions chimed with his own burgeoning sense of purpose, the Pre-Raphaelites, and above all Dante Gabriel Rossetti.

Morris and Burne-Jones had found solace in the city of Oxford itself, then fundamentally the medieval city despite the recent arrival of modernity in the form of the railway. Oxford to Morris was 'a vision of grey-roofed houses and a long winding street and the sound of many bells', and the city expressed for both of them their discovery of the medieval as an exemplum of the spiritual values and realities lacking in nineteenth-century life. It was this romantic medievalism that found its essential artistic expression and imagery in the art of Rossetti.[3] Morris and Burne-Jones had encountered Rossetti first in the pages of Ruskin's Edinburgh lectures (1854). When they saw the artist's *The First Anniversary of the Death of Beatrice* of 1853–4 (fig.5), now in the Ashmolean Museum, Oxford, and then in the collection of the director of the Clarendon Press, the Anglo-Catholic Thomas Combe, Burne-Jones thought it 'our greatest wonder and delight'.[4] Rossetti's romanticism, describing a high-keyed image of the medieval as a time when spiritual suffering and intensity were the stuff of life and the false comforts of the material world were spurned in their favour, appealed strongly to the two undergraduates. This vision formed 'the perfect climax to their early aspirations' now that their ambitions for a dedicated spiritual life had switched from the Church and Anglo-Catholicism to the role of the heroic artist.[5] Inspired by what he had seen and read, Burne-Jones approached Rossetti in London in January 1856 and was almost immediately invited to visit the latter's studios in Blackfriars.

5 Dante Gabriel Rossetti
The First Anniversary of the Death of Beatrice 1853–4
Watercolour
42 × 61 (16½ × 24)
Ashmolean Museum, Oxford

At the same time Morris had joined the architectural practice of G.E. Street, moved to London, and was busy forging his own career. Perhaps inspired by this, Burne-Jones himself left Oxford in May 1856 without taking his degree and moved to London to study with Rossetti and to establish himself as an artist in the Metropolis.

At Oxford, Morris and Burne-Jones had entertained and inspired each other by reading not only genuine medieval works, such as Malory's *Morte D'Arthur* and the poetry of Chaucer, which had enraptured them with 'strength and beauty, its mystical religion and noble chivalry of action, the world of lost history and romance', but also modern medievalising tales of chivalry and knightly dedication and brotherhood.[6] Works like Kenelm Digby's *Broadstone of Honour: or, Rules for the Gentlemen of England* (1822–3) and Tennyson's *Sir Galahad* (1842) offered them an image of a tightly knit group of chivalrous friends who would rescue the fallen world for truth and spirituality. 'I have set my heart on our founding a brotherhood', wrote Burne-Jones to a Birmingham friend at this time, 'learn Sir Galahad by heart. He is to be the patron of our Order.'[7] Rossetti's London networks presented themselves to the newly metropolitan Burne-Jones in something like this light. Almost before he knew it, Burne-Jones found himself acquainted with the Pre-Raphaelite circle, the painter G.F. Watts and his glittering group at Little Holland House in Kensington, and – heart-stoppingly – Ruskin himself: 'I'm not E.C.B. Jones now', he wrote to a friend, 'my future title is "the man who wrote to Ruskin and got an answer by return".'[8] Burne-Jones found himself in a high-powered and intensely supportive extended network focused on medievalism, the need for a new art to set against the realities of contemporary society, and with a strong belief in the possible priestly role of the artist in the modern world. Watts, like Rossetti in his different way, provided Burne-Jones with an image of the dedicated artist, labouring to elucidate reality for his audience and with a profound belief in his own interpretive powers. Rossetti's example in particular, inculcated by inspirational but sporadic lessons in technique, remained with Burne-Jones through his life: 'he taught me to have no fear or shame of my own ideas', said Burne-Jones, 'to design perpetually, to seek no popularity, to be altogether myself'.[9]

The first real attempt to carry out a programme of work developed from this context was at the new Oxford Union Society, where Rossetti and members of his circle – including Morris, who had now left Street's office and was attempting to be a painter, Val Prinsep and Spencer Stanhope, together with Swinburne, who joined the group during their stay in Oxford – undertook a scheme of murals on the walls in 1857 (fig.6). The artists had no idea about mural technique and the paintings almost immediately began to fade and are now barely visible. The significance of the commission, in which Rossetti's interest soon waned, was as an instance of the ambition to be and act as a group or Brotherhood. Ruskin, who had been instrumental in the work, found himself explaining this to the architect: 'you know the fact is they're all the least bit crazy and it is very difficult to manage them'.[10]

Burne-Jones's own art had to develop elsewhere, at first largely in the form of the drawings he produced under the influence of Rossetti who was himself

primarily working in pen and ink during this period. While still a student, Burne-Jones had produced in 1854–6 a series of illustrations for Archibald Maclaren's *The Fairy Family: A Series of Ballards and Metrical Tales Illustrating the Fairy Faith of Europe* (1857; fig.7). The detail and precision of these designs, as well as their intense romanticism, bore fruit in the late 1850s when Burne-Jones started to work under Rossetti. With the injunctions of Ruskin to attend

6 The Old Debating Hall, Oxford Union Society, showing part of the murals of 1857

7 Design for 'The Fairy Family': The Elf-Folk, illustration for Archibald Maclaren, The Fairy Family: A Series of Ballards and Metrical Tales Illustrating the Fairy Faith of Europe 1857 The Pierpont Morgan Library, New York

minutely to finish and the particularities of the motif in mind, he began to produce a series of highly worked and elaborated pen and ink drawings which mingle Rossetti's romantic medievalism with Ruskin's focus on the smallest levels of reality, 'rejecting nothing, selecting nothing, and scorning nothing'.[11]

Sir Galahad (1858; fig.8) and Going to the Battle (1858; fig.9) are representative of Burne-Jones's drawings of this period. Made with pen and ink on vellum, and in the case of Going to the Battle with the addition of a grey wash, they offer romantic and imaginative visions of the Middle Ages. Going to the Battle has an extraordinary level of detail. The landscape is minutely rendered

in the best Ruskin-approved manner, from the farthest background, where agricultural and architectural details of the surrounding countryside can be clearly made out, to the nearest foreground, where individual blades of grass and details of the physiology of the flowers are sharply rendered. Each link of the parrot's chain and each detail of its feathers are described, and the clearly differentiated dresses of the three women are given their own individual variations of form, fabric and decoration. Each woman is distinguished by the style of her hair, with the texture of each very closely described, an effect achieved here as elsewhere in the drawing by precisely controlled cross-hatching to produce tonal and textural detail. This richness of visual event is focused by a single narrative episode, the rather poignant exchange of glances between the watching women and the single, representative figure of the knight riding past to death or glory, a device that Burne-Jones returned to much later in *Laus Veneris* (1873–8; fig.36).

Oscar Wilde once said that the visual arts were inferior to literature because the latter could represent time and the former could not. But drawing and painting of the type these works represent provide their own versions of time and narrative, quintessentially visual ones. The pleasures of the drawings are the pleasures of an attention minute enough to match the precision and detail of the description of the worlds that they present to us. Enjoyment depends

8 *Sir Galahad* 1858
Black ink on vellum
15.6 × 19.2
(6⅛ × 7½)
Fogg Art Museum,
Harvard University
Art Museums,
Bequest of Grenville
L. Winthrop

9 *Going to the Battle*
1858
Pen and ink with
grey wash on vellum
22.5 × 19.5
(8⅞ × 7¾)
Fitzwilliam Museum,
Cambridge

upon a connoisseur's discrimination of the varied textures and details, and a slow, focused movement of the eyes over the surface of the drawing, engaging with each aspect and moment of the visual story in turn. As we move from one visual incident to another we undergo an experience which is both narrative, that is based in the unfolding process of time, and concerned with depth, as we look intently at the levels of detail on the surface of the vellum and sink slowly through each one, building up a palimpsest of incident and event. Small wonder that Ruskin thought these drawings 'marvels in finish and imaginative detail'.[12]

The limits of this undertaking are indicated by another drawing, *Buondelmonte's Wedding* (1859; fig.10), a subject from Florentine history. At 10 × 30 in (25.5 × 77 cm), this is a very large and ambitious work indeed. Despite the scale on which he is working, Burne-Jones still describes the imaginative world of his drawing in the sort of minutely rendered detail recommended by Ruskin. Furthermore, unlike *Sir Galahad* or *Going to the Battle*, both of which are in reality drawings of emotional circumstance rather than of historical incident, *Buondelmonte's Wedding* provides something of the circumstantial history leading up to the marriage. The story depends on a knowledge of a

10 *Buondelmonte's Wedding* 1859
Pen and ink with grey wash on vellum
25.5 × 77 (10 × 30)
Fitzwilliam Museum, Cambridge

typical Rossettian subject, the history of the competing Florentine clans of the Guelphs and the Ghibellines. The vignette on the far left shows the Guelph matriarch Gualdrada Donati presenting her daughter to Buondelmonte in an effort to persuade him to marry into her family in preference to the rival Ghibelline clan. Burne-Jones also indicates the outcome, a feud and eventually Buondelmonte's murder, seen in the centre of the composition, at the statue of Mars on the Ponte Vecchio. The rest of the vellum is filled with architectural and landscape detail and an account of the multifarious wedding preparations.

The awkwardnesses of draughtsmanship in *Buondelmonte's Wedding*, a consequence of Burne-Jones's meagre training, are no greater than those in *Going to the Battle*. But the overall effect of this drawing is much less persuasive than that of the smaller vellum. This is partly because of the greater prominence of the figures, but it is also a function of its much larger size which reduces the impact of the precise detail and encourages the fragmentation of the more complex storyline into separate narrative or visual phases. The sheer scale of the undertaking gives the individual episodes less substance and causes them to be less finely conceived than is the case in the smaller drawing. *Buondelmonte's Wedding* is a demonstration that Ruskinian minute detail and a large scale and narrative subject do not easily mix. Burne-Jones was going to have to find a way to bring these two competing – and arguably incompatible – aspects of his art together, to make images that contained both meaning and narrative intensity, and visual incident and detail of an equally compelling sort.

Burne-Jones's other work at this time foreshadowed his future development in various directions. In 1857 he received his first stained-glass commission, *The Good Shepherd* (United Reformed Church, Maidstone), and produced a design, executed for the church a few years later, in 1861 (fig.11), which showed a 'remarkable ... understanding of two-dimensional design' for a largely self-educated artist 'with no formal training or previous experience'.[13] Ruskin, impressed by the modesty and naturalism of the representation of Christ as a real shepherd, was reported to have been 'driven wild with joy' by the image.[14] This burgeoning talent for design was already being exploited by Morris, whose housemate Burne-Jones had become in 1856. At their lodgings at 17 Red Lion Square in Bloomsbury the two men continued to fill each other with tales of chivalric romance, and, driven by the imperative to translate the spiritual and authentic values they discerned in the romantic medieval world

21

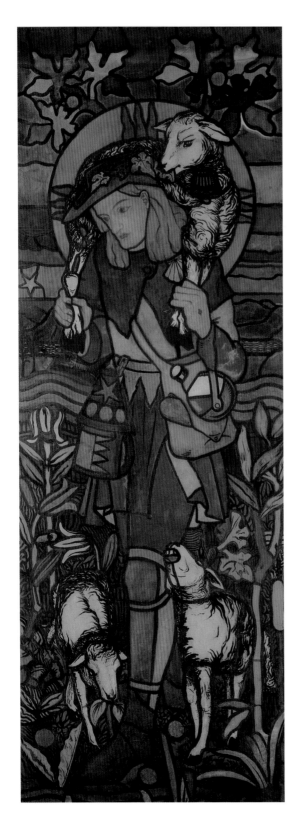

11 *The Good
Shepherd* (cartoon for
stained-glass panel)
1857
Watercolour and ink
128 × 47.7
(50⅜ × 18¾)
Victoria & Albert
Museum, London

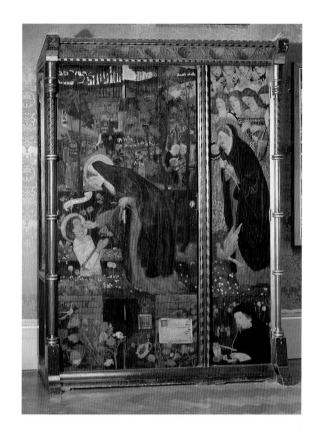

12 Edward Burne-Jones and Philip Webb (designer) *The Prioress's Tale Wardrobe* 1859 Oil on oak and deal 221 × 158 × 54.5 (87 × 62¼ × 21½) Ashmolean Museum, Oxford

of their imaginations into the realities of the nineteenth century, they began to experiment with domestic design. Burne-Jones's painting on *The Prioress's Tale Wardrobe* (1859; fig.12), a piece of furniture designed for Morris by Philip Webb, is in fact his first major oil painting, but really shows better the early strength of his talents as a designer. These activities were to provide an important source of income for Burne-Jones and to support him through the early phases of his career when he was making relatively little money from other sources.

The most compelling of Burne-Jones's requirements for a regular source of income was marriage. He had met Georgiana Macdonald, the daughter of a Methodist minister, in the late 1850s, and almost immediately began to court her. They married in 1860 after a four-year engagement, on the highly romantic date of 9 June, the anniversary of the death of Dante's Beatrice; they settled at 62 Great Russell Street, near Red Lion Square – which was now converted into a 'shop' for William Morris's artistic collective, 'The Firm'. A son, Philip, was born in 1861 and a daughter named Margaret in 1866. Their second child, a son named Christopher, died after only three weeks in 1864. This intense family life brought increased responsibilities for Burne-Jones and provided the context for the advancement of his career.

'The Firm' – or Morris, Marshall, Faulkner & Co. as it was called – drew on a group of designers, makers and artists including Ford Madox Brown, Charles Faulkner, Rossetti, P.P. Marshall, Morris and Philip Webb, whose

ambition it was to step outside the mechanical routines of modern mass-production and industrialised design and manufacture. Deeply indebted to Pugin and the Anglo-Catholic tradition, The Firm aimed to make household and practical objects using methods similar to medieval artisanal practice, providing an environment in which values other than the materialistic could flourish. For some years to come, stained-glass designs and other design work for The Firm stocked the Burne-Jones larder, as marriage and the advent of children made increasing demands on his purse.

In the early 1860s, and still under the influence of Rossetti, Burne-Jones began to paint watercolours in which the concerns of his early drawings were further explored in ways that were to be significant for his later work. In *Sidonia von Bork* (fig.13) and *Clara von Bork* (fig.14), both made in 1860, he put aside both medievalism, at least in the strictly chronological sense (these are sixteenth-century subjects) and Ruskinian detail. The advent of colour and the physical properties of watercolour and gouache turn Burne-Jones's interests away from the precision of the pen drawings that had reached an impasse

Below left
13 *Sidonia von Bork*
1860
Watercolour and bodycolour
33.3 × 17.1
(13⅛ × 6¾)
Tate

Below right
14 *Clara von Bork*
1860
Watercolour and gouache
34.2 × 17.9
(13½ × 7)
Tate

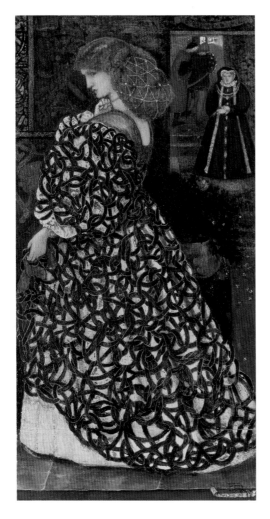

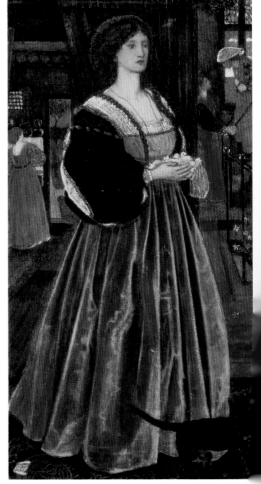

with *Buondelmonte's Wedding*, to a new concern with the visual qualities that might be coaxed from other media.

But if these watercolours cast off some aspects of the concerns of earlier years, they also perpetuate others. The two 1860 portraits show two different women from Johann Wilhelm Meinhold's gothic romance *Sidonia the Sorceress*, which had been translated and published in English in 1849. It has been suggested that, while the figure of Sidonia is modelled on Fanny Cornforth, Rossetti's worldly mistress whose open sexuality often seems to have discomforted the rather shy Burne-Jones, Clara is a portrait of Georgie, his new wife, and an image of innocence and erotic decorum.[15] But it is not entirely clear which figure evokes the greater interest from the artist. Sidonia heralds the appearance of a whole series of figures of female menace and power in Burne-Jones's art. A murderess and a witch, she fits easily into the erotic obsessions of Rossetti and Swinburne, both of whom Burne-Jones was close to at this time and both of whom were preoccupied with the occult and the gothic, and with demonic women as images and symbols of these qualities. By contrast, it may very well be that the innocent Clara, who represents the opposite principle to her evil cousin in Meinhold's novel, stands for a more personal and perhaps more aspirational principle for Burne-Jones. Nonetheless, it was to be an aspiration that in some ways proved hard to realise, and the demonic woman continued to appear in Burne-Jones's subsequent works.

Another watercolour, *Merlin and Nimue* (1861; fig.15), combines medievalism and the figure of the demonic woman. Fanny Cornforth once again stands in for the *femme fatale*, weaving her spells to subdue and imprison Merlin in a grave. Burne-Jones derived the subject from Malory, his favourite reading with Morris. He copied out on the back of the original frame a brief passage from Malory's account: 'The enchantment of Nimue: how by subtility she caused Merlin to pass under a heavy stone into a grave.'[16] Nimue's motive is the desire to avoid Merlin's unwelcome sexual attentions, a subject which Burne-Jones converts into a deeply romantic and melancholy moment of loss in which the agent of that melancholy is the slyly plotting Nimue. Whether this particular handling of the subject reflects some aspect of Burne-Jones's inner life is perhaps less important than the fact that a serpent is inserted into the garden of colour and form: narrative and 'plotting' in both its meanings intrude into the still world of the mountains and valley in which the scene is set. But this is not an irreconcilable clash. These contrasting elements are perhaps not so much opposites or combatants as distinct but equal participants in the image. Although Burne-Jones's technical skill in the handling of watercolour and other paints was not well developed at this time, he was already using colour and light to create emotional texture and effect, balancing these against sharply observed qualities of the narrative: the bewilderment of Merlin and the sly pleasure with which Nimue registers the success of her spell.

This fascination with the power of the visual to induce meaning as profound and particular as the world of words found a new focus during the 1860s, as the interests of Burne-Jones's circle began to shift away from the medieval and towards the art of Venice. The most famous results of this development are Rossetti's great half-length paintings of women from the 1860s

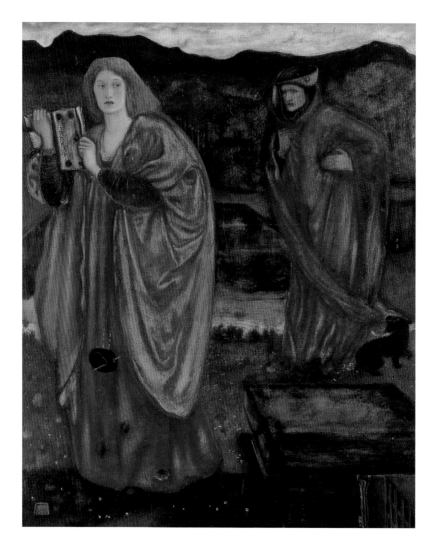

15 *Merlin and Nimue*
1861
Watercolour and
bodycolour
107.5 × 94.5
(42⅜ × 37¼)
Victoria & Albert
Museum, London

such as *The Beloved* (1865–6; fig.16) in the Tate. But it was a trip to Italy in the summer of 1862 with Ruskin, who paid for everything in return for copies of Old Master works, which provided the real occasion for this extension of Burne-Jones's sensibility and repertoire. Ruskin's fascination with Venetian art was to appear in the final volume of his *Modern Painters* in 1860, and he was already showing impatience with Burne-Jones's medievalism. The majority of the copies Burne-Jones made during the months spent in northern Italy are therefore of works by Venetian and other northern Italian artists, including Titian, Tintoretto, Veronese, Bernardino Luini and Giorgione.

Burne-Jones occasionally chafed under the discipline that copying imposed: 'one could do a dozen designs for one little worthless copy', he complained to Ruskin, 'but oh, it does one good'.[17] His 'Renaissance' water-colours of Clara and Sidonia Von Bork (see p.24) are among the first fruits of his interest in new areas. The sensuous attention to material surfaces and paint textures and his intense use of colour and impasto provided Burne-Jones

with models for the manipulation of paint which chimed well with his ambitions to produce an art of spiritual weight and truthfulness. Later in his life he remembered the impact of his stays in Venice: 'when I came back thinking there could be no painting in the world but Carpaccio's and the other Venetians'.[18] It was not just the colour that provoked this conviction, but the sense of a sensuous materiality placed at the service of spiritual meaning.

Under the influence of the Venetians, and above all of Giorgione, in his watercolour called *Green Summer* (1864; fig.17) Burne-Jones produced his own version of the *fête champêtre*, a genre which had been particularly Giorgione's. Burne-Jones arranges a group of seven green-clad women – his wife and her sisters observed in Abbey Woods in Kent – all young, all talented, but all touched by experience. The title is derived from Malory: *Green Summer* is that moment of fulfilment before 'winter rasure doth … erase and deface green summer' as 'true love' does its happiness.[19] Fulfilment, then, is already marked by its transitoriness, the obliteration which will surely come; the weight of experience, of apprehension, knowledge and desire, is written across the youthful faces of his models. Penelope Fitzgerald expresses this

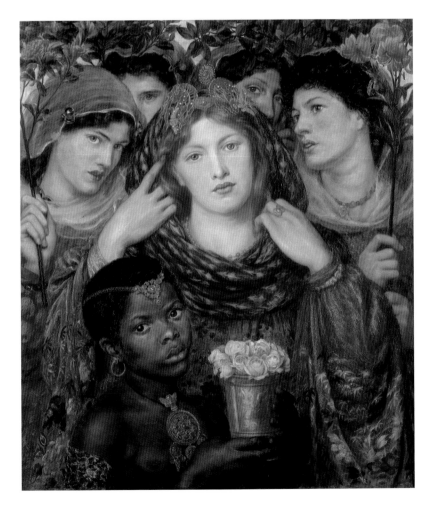

16 Dante Gabriel
Rossetti
The Beloved 1865–6
['*The Bride*']
Oil on canvas
82.5 × 76.2
(32½ × 30)
Tate

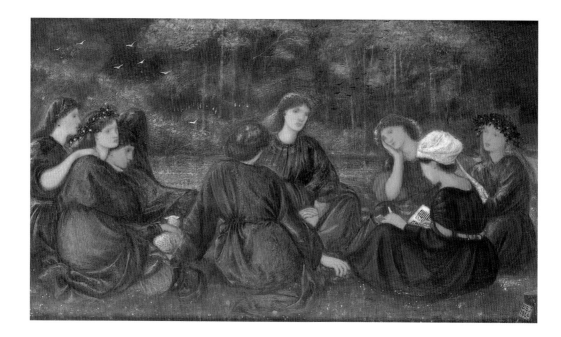

well by describing the sisters' attentive image of 'beauty guilty of its own mortality'.[20] This is a version of the intrusion of knowledge into the garden of innocence that *Merlin and Nimue* also presents: the greens of nature and the women's clothing blend them into each other in an identity of colour, while contemplation, the meditative preoccupation of their faces, separates them from each other even as they are united, breaking their identity into a series of individuals laid bare before fate and time.

Green Summer represents the moment at which Burne-Jones's art becomes truly individual. He now embraces fully and for the first time the implications of his desire to find a visual format that would embody and communicate the spiritual truths that he had learnt to value through Carlyle and Ruskin, and the thinkers of the Tractarian movement. The still, contemplative inwardness of *Green Summer*, its sense of the consciousness of a melancholy fate at the very moment of fulfilment, expresses a belief in emotional and spiritual values and meanings beyond the grim materialism of the time. In the years that followed the mid-1860s Burne-Jones was to develop and elaborate this vision in a series of works of increasing visual sophistication and focused significance.

17 *Green Summer*
1864
Gouache on paper
29 × 48.5
(11⅜ × 19⅛)
Private collection

2

EXILE AND ACHIEVEMENT

18 *Le Chant d'Amour* 1865
Watercolour with bodycolour on paper mounted on panel
Sight: 54.9 × 77.7
(21⅝ × 30⁹⁄₁₆)
Frame: 86.5 × 109.5
(34¹⁄₁₆ × 43⅛)
Museum of Fine Arts, Boston.
Bequest of Martin Brimmer

By 1870 anyone looking at Burne-Jones might have been forgiven for believing that he was firmly established. He had built the experience of Italy and his early apprentice years into an individual style which was widely acknowledged as forceful and particular in technique and emotional tone. His capacity to produce a visual poetry in such works as his Giorgionesque *Le Chant d'Amour* of 1865 (fig.18), which matched the poetry of the melancholy heart, had earned him a group of followers, including William De Morgan and Walter Crane, and a group of loyal patrons who regularly bought and commissioned his work. His art was increasingly sophisticated and individual, both technically and in its themes; he was receiving recognition of the kind implied by his election to the Old Water-Colour Society in 1864, and beyond all this he had a solid family life to support him in his professional endeavours. When in 1870 he showed at the Old Water-Colour Society, the moment might have been taken to mark the confirmation of his secure public status. But this was not the way things turned out. The scandal that erupted around *Phyllis*

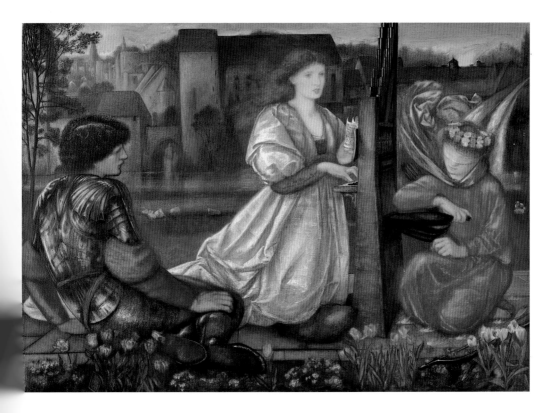

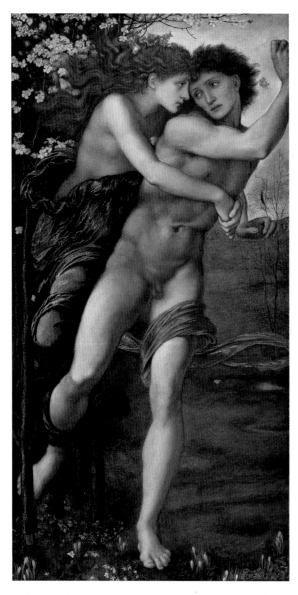

19 *Phyllis and Demophoön* 1870 Watercolour and bodycolour and gum 91.5 × 45.8 (36 × 18) Birmingham Museums & Art Gallery

and Demophoön (1870; fig.19), one of the works he showed at the exhibition, was to precipitate Burne-Jones into depression, eventually leading him into seven 'desolate years' of withdrawal from the public eye. But this was an experience that turned out to be of vital importance for the future development of his art and reputation.

The question of decency in the depiction of the nude was a live one for the Victorian audience. A series of very public debates had failed to resolve matters or find much in the way of common ground in the representation of the body, and the frankness of the male nude in *Phyllis and Demophoön* could only be read as provocation in the conservative setting of the Old Water-Colour Society. Burne-Jones's determinedly passive-aggressive Phyllis and the fearful and unhappy Demophoön seemed to contemporary commentators to be too

degenerate in their relationship to support the idea of a healthy or celebratory depiction of their nudity. Nothing could be less heroic or manly in the Victorian sense than Demophoön's simultaneous cringing and longing. His explicit debt to the classicising traditions of the High Renaissance in the depiction of the male nude, and the respectably classical subject, drawn from Ovid, were not enough to offset the figure's lack of decent covering. The critic of the *Illustrated London News* summed this up, thinking the picture 'something which, like the amatory poetry of the Swinburne school, might be loathsome were it not for its fantastic unreality'.[1] It was this 'unreality' – the same critic thought it 'nothing but a stony, bloodless figment of the fancy' – that disturbed the critics. Burne-Jones had produced something which dealt with experience outside the conventional or familiar, and he was taken to task for it in the considerable notice the picture received. Such willingness to tackle an unusual or emotionally oblique subject was seen to imply decadence or degeneration, as the reference to Swinburne makes clear.

The Society and its officers seem to have been disturbed by the attention given to Burne-Jones, and moved fast to avoid or mitigate a full-blown scandal. Frederick Taylor, the President, had a conversation with the painter, the result of which was a flat refusal to compromise: Burne-Jones 'declined to make some slight alteration in removable chalk, and withdrew not only the picture from the walls but himself from the Society'.[2] He waited until the end of the exhibition before resigning, citing the need for 'absolute freedom in my work', but the picture came down from the walls immediately.[3]

The obvious cause of the scandal of 1870 may have been Demophoön's nudity, but there was another aspect to the picture which may have compounded its sexual irregularity. Since 1866 Burne-Jones had been conducting an increasingly passionate and physical affair with the Anglo-Greek Maria Zambaco, later a considerable sculptor (fig.20), and it is her face that he gave to Phyllis in the painting. Their relationship seems to have given Burne-Jones enormous emotional pain, not least because of the unfailing loyalty of his wife and his own theoretical devotion to the idea of a united and secure family. He repeatedly attempted to end the affair, and there were several incidents involving Zambaco, including one which saw her 'howling like Cassandra', as Rossetti reported in a letter, threatening laudanum, and attempting 'to drown herself in the water in front of Browning's house &c. – bobbies collaring Ned who was rolling with her on the stones to prevent it'. At the high-point of this emotional turmoil Burne-Jones and Morris could be glimpsed on the quay at Dover, planning to flee to the Continent to escape the situation.[4]

Some, at least, of all this must have been public knowledge when Burne-Jones introduced the soulfully clinging figure of Phyllis into his painting. 'Poor old Ned's affairs have come to a smash altogether', wrote Rossetti in the same letter; the whole business may have made Burne-Jones more eager than he might otherwise have been to embrace the opportunity offered by the Old Water-Colour Society's pusillanimity and to retreat from the public gaze for a period. Although he attributed his decision to a 'complete want of sympathy between us in matters of Art' in his resignation letter to the Society's governing body, it may have been more a question of a lack of sympathy with the

31

glare of publicity that drove him 'to regain his freedom', as Georgiana put it later.[5]

20 *Portrait of Maria Therasa Zambaco*
1870
Gouache
76.5 × 55
(30⅛ × 21⅝)
Clemens-Sels-Museum, Neuss

But this moment – when Burne-Jones did genuinely seem to have felt himself to be embattled on all sides, with a questionable artistic achievement and lack of support from any quarter, the troubles of his personal life compounding his insecure professional status – in retrospect seems also to mark his ascent into his most magnificent period. Georgiana speaks of the time that followed as the 'seven plenteous years', and Burne-Jones himself thought them 'the seven blissfullest years of work I ever had; no fuss, no publicity, no teasing about exhibiting, no getting pictures done against time'.[6] A set of established and wealthy patrons such as Frederick Leyland, who bought *Phyllis and Demophoön*, and William Graham released him from the obligations of public exhibition and judgement, thus enabling him to build on developments in his art which had been in progress since the early 1860s.

The 1862 trip to Italy with Ruskin had helped to provoke the changes in Burne-Jones's art introduced under the influence of the Venetians. Now, depressed and sleeping badly in the aftermath of the Old Water-Colour Society affair, and on the proceeds of some design work in stained glass, he resolved to return to Italy. He sought more than merely physical or even psychological refreshment. The individuality of his technical procedures, treating watercolour with gum and bodycolour to obtain a medium that could be applied like oil paint, as it is in *Green Summer* and *Phyllis and Demophoön*, placed Burne-Jones at some distance from the conventional techniques and interests of his professional peers, and probably inspired 'the conviction that my work is antagonistic to yours' that he cited in his resignation letter to the Old Water-Colour Society.[7] Reflecting on the 1871 trip to Italy and its effect in 'making me live again', he blamed his depression upon 'the increasing feeling' of his work's 'eccentricity as every year I found myself more alone in it' and the consequent 'miserable feeling of being a mistake'.[8] To return to Italy – visiting Pisa, Florence, Assisi and Arezzo, among other cities, as well as Rome for the first time – was to reconfirm for him the integrity of his art and to enable him to trust his instincts again. He belonged to Italy, he wrote, and that assertion, or recognition, revivified his art.

Under the pressure of these experiences, the Venetian and Giorgionesque effects of *Green Summer* and the melancholy eroticism of *Le Chant d'Amour* in the same idiom now gave way to the influence of painters from the other Italian Renaissance centres, among them Signorelli, Pollaiuolo, Piero della Francesca, Michelangelo and Botticelli. He had already begun to be influenced by the example of the description of ideal bodies in Greek sculpture, and the *Memorials* reveal Burne-Jones visiting the Sistine Chapel: 'he bought the best opera glasses he could find, folded his railway rug thickly, and lying down on his back, read the ceiling from beginning to end, peering into every corner and revelling in its execution'.[9]

At this point he began to move away from watercolour as his major medium and resolved to work increasingly in oil. The appearance of his art became clearer and more limpid, eschewing the muddy surfaces of his watercolours. During these years the experience of designing sets of narrative wall tiles for

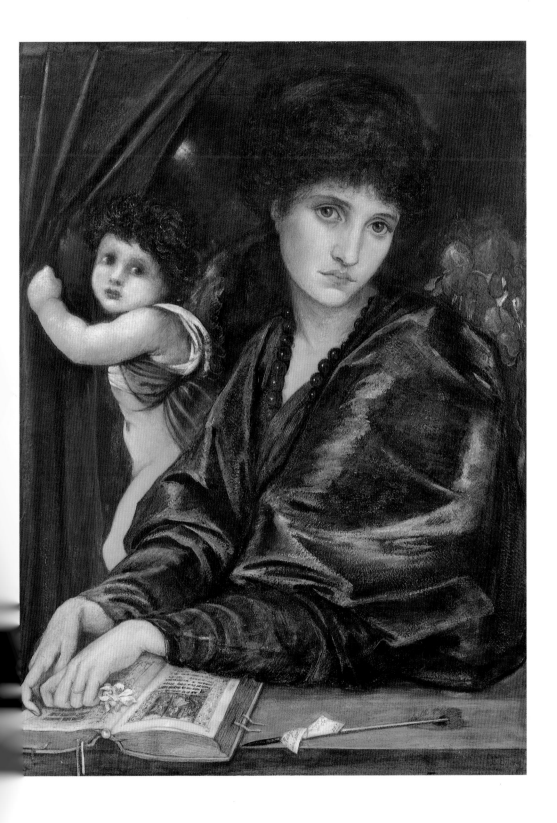

Morris's Firm, including series depicting the stories of *Cinderella* (1863–4) and *Sleeping Beauty* (1864), gave Burne-Jones his first real taste of extending narration from single to serial images. At the same time he wished to extend the effects of his work by painting on a scale that watercolour and bodycolour do not allow. 'I want big things to do and vast spaces', he said, 'and for common people to see them and say Oh! – only Oh!'[10]

The years immediately following his return from Italy in 1871 proved extraordinarily productive. He made designs at a pace which outstripped his ability to execute them, and paintings, canvases, sketches and designs littered the 'augean stables' of his studio floor, while he was obliged to take on studio assistants – most notably T.M. Rooke – to help him cope with the mismatch between the intensity and range of his creativity and his capacity to complete the work he began in his creative ferment.

If he was to achieve the large-scale effects he now sought, Burne-Jones swiftly saw that he would have to develop the technical skill of his painting and drawing. Smarting under repeated comments from the press, and from friends such as, memorably, G.F. Watts, on the inadequacy of his drawing, Burne-Jones began at this time to produce large numbers of preparatory sketches for his works and to set himself to master the Renaissance accuracy in drawing, physiology and perspective. A further trip to Italy in 1873, when he visited Siena, Bologna and Ravenna, helped to confirm these developments in his art. A representative sketchbook from this trip, now in the Fitzwilliam Museum in Cambridge, contains 28 folios of pencil drawings which mix architectural scenes, mainly of Siena (fig.21), with careful copies from Old Master

Below left
21 *Street in Siena near the Duomo* 1873
Graphite on paper
25.4 × 17.9 (10 × 7)
Fitzwilliam Museum, Cambridge

Below right
22 Copy of *Two Saints after Mantegna* 1873
Graphite on paper
25.4 × 17.9 (10 × 7)
Fitzwilliam Museum, Cambridge

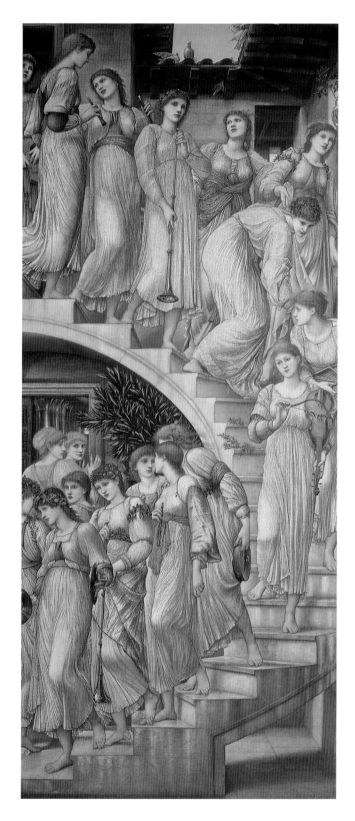

23 *The Golden Stair*
1876–80
Oil on canvas
269.2 × 116.8
(106 × 46)
Tate

paintings and a few details he had observed in public and private sculpture (fig.22). Over the next years he filled many similar sketchbooks with records of what he had seen and imagined, returning repeatedly to the nude and to life models and striving to develop an idiom which would be both an accurate record of what he was seeing as well as the instrument of a spiritual and imaginative engagement with the world.

The paintings that Burne-Jones made in this new and evolving idiom were frequently executed over years, sharing workspace and competing for attention with a large number of other designs, canvases and projects, all at various stages of completion. At such moments, when Burne-Jones's art changes swiftly or in complex ways, his tendency to continue working on individual pictures as his style and technique evolved makes many of his works representative of periods at some distance from the date of their first exhibition. Although his slow-moving methods of execution meant that *The Golden Stair* (fig.23) was not finished until 1880, it was conceived and designed in the aftermath of the 1871 Italian trip, and it represents the effects of that experience. The pale clarity of the colour harmonies and the stylised rhythms of the draperies give the painting a languid but persistent sense of purpose which is reinforced by the line of descending girls slowly unwinding towards the foot of the stairs. In 1880 the *Times* critic thought the faces of the girls 'sad rather than joyous, but with a sadness that is tender and pleasing, not woeful and worn out'; Burne-Jones's melancholy theme of the inevitable vanishing away of love, the intensity and sweetness of Venus and her passing, are all caught here at the highpoint of his career.[11] To underline the point, Burne-Jones's Mary is also melancholy, in *The Annunciation* of 1876–9 (fig.24). This painting combines the artist's architectural and decorative interests kindled in Italy with his own versions of figures he had been studying in the works of the Italian masters.

In view of the intensity and speed of change and the period of fierce creativity Burne-Jones experienced after 1871, it is no wonder that the idea of art itself should appear in the works he produced during these years. Between 1875 and 1878 he designed and executed a series of four works on the theme of *Pygmalion and the Image* (figs.25–8). Appropriately enough, his interest in producing paintings in series reflects Burne-Jones's desire to work on an augmented scale and to dazzle his audience with the range and brilliance of his art. The Pygmalion theme deals with the creative capacity of the artist and the connections between his work and the realities of his life and experience. In Ovid's *Metamorphoses* Pygmalion is a king as well as a sculptor and so wields power in the two realms of action and imagination. He must, however, face the compulsive power of the second when he conceives and then creates a marble statue, Galatea, whose beauty is such that he falls in love with his own creation. Venus, out of regard for him, transforms the cold marble into living flesh and presents the grateful king with a real woman to worship. Here is a parable of the relationship between action and imagination, the world and creation, in the work of art. Burne-Jones's art is famously hermetic: he transforms the world, his models for instance, into the instantly recognisable expressions of his own vision as soon as he begins to draw. Pygmalion has a

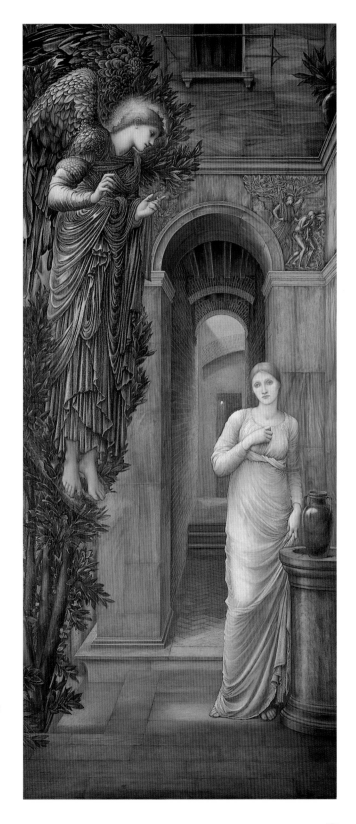

24 *The Annunciation*
1876–9
Oil on canvas
250 × 104
(98⅖ × 41)
National Museums
Liverpool (Lady
Lever Art Gallery)

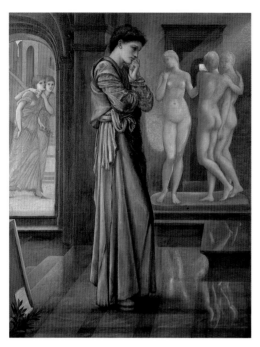

25 *Pygmalion and the Image 1: The Heart Desires* 1875–8
Oil on canvas 99 × 76.3 (39 × 30)
Birmingham Museums & Art Gallery

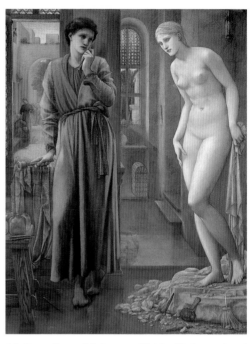

26 *Pygmalion and the Image 2: The Hand Refrains* 1875–8
Oil on canvas 99 × 76.3 (39 × 30)
Birmingham Museums & Art Gallery

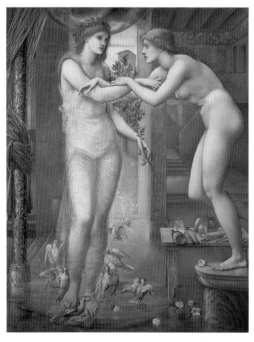

27 *Pygmalion and the Image 3: The Godhead Fires* 1875–8
Oil on canvas 99 × 76.3 (39 × 30)
Birmingham Museums & Art Gallery

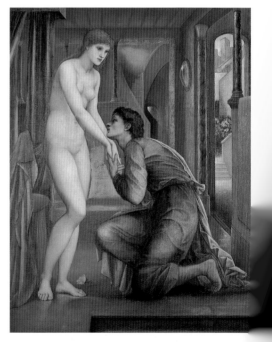

28 *Pygmalion and the Image 4: The Soul Attains* 1875–8
Oil on canvas 99 × 76.3 (39 × 30)
Birmingham Museums & Art Gallery

complex, paradoxical relationship with this creative transformation. Although himself the creator of his woman of flesh and marble, and despite the realisation of his most earnest wish, he cannot control her and is compelled to fall to his knees in supplication before her. The act of creation is not merely his, but also, or perhaps more so, that of Venus, who seizes the imaginative force of his sculpture and makes a living being out of it. What began as opposed to action and the world ends up, in the final painting, in thrall to it. The artist finds himself unable to take control and act. Even at the moment when he has succeeded in creating something capable of action, the transformation is attributed to an external force in the form of the goddess. The king and Galatea are now faced with living out their lives. No wonder they both look so distracted and apprehensive: the responsibility of a happy outcome now lies with them, for the intensity of art is not enough.

This melancholy mixture of desire and scepticism about the capacity of art to affect the world in any meaningful sense perhaps also underlies the sequence of works that Burne-Jones had produced since his earliest years as a professional artist. The series which includes *Le Chant d'Amour* and *The Lament* (1865–6; fig.29), as well as the first Briar Rose series, presents music as the

29 *The Lament*
1865–6
Watercolour and bodycolour on paper over canvas
47.5 × 79.5
(18¾ × 31¼)
William Morris Gallery, London

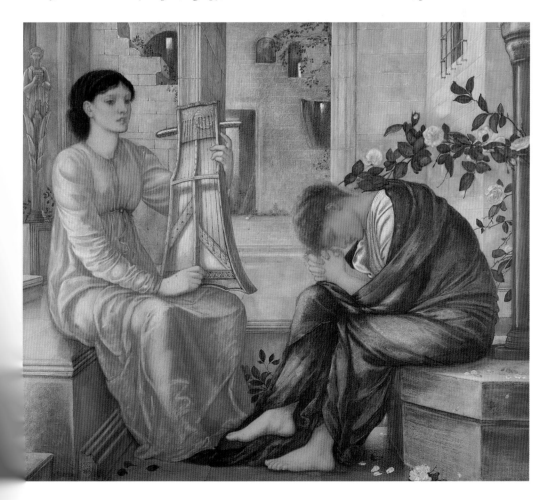

embodiment of powerful but depressive emotional forces. The right-hand figure in *The Lament* seems lost in some overwhelming interior experience after listening to the music her companion has just finished playing. There is no other subject but this moment of lyrical, suffering emotional intensity provoked by art. Preceding the Pygmalion series, *The Lament* proposes a profound effectiveness for art, but depicts its effect as a sudden immobility, a pause in the swing and purpose of life, an intense interior moment or event which translates the recipient or sufferer out of the normal rhythms of existence and into another and perhaps incompatible world.

The Michelangelesque nudes of *The Wheel of Fortune* (1875–83; fig.30), kings and beggars alike revolving slowly on the cycle of life and bound to endure, unable to direct their own lives or fates, provide another image of passivity and incapacity before life. 'My Fortune's Wheel is a true image', wrote Burne-Jones, 'and we take our turn at it and are broken upon it'; the picture distils this central preoccupation of his work with the challenge of action and the role of art.[12] As a physical object the painting seems to strive to overcome this melancholic message. It is huge (78 × 39 in; 199 × 100 cm), and its rigorous 1:2 ratio of height to breadth reinforces the effect of massiveness as it towers over the spectator. Burne-Jones asserts the difficulties faced by art in seeking to alter or change entirely the world of experience for its audience, but he emphasises its power and affect at the same time. The sheer size of *The Wheel of Fortune*, like his interest in painted series and the implicit claims of a new, fluent and technically adroit use of oil paint, are all part of the new scale of Burne-Jones's ambitions in this period of research and change. But they are matched at the same time by his persistent anxiety about the influence of art and the power that the artist might wield for good or ill. Heir to the explicit injunction to make a difference and affect a change that Ruskin, Carlyle and Newman had all urged, Burne-Jones found himself having to wrestle with such a demand of his art at a time when it, like that of many of his contemporaries, seemed best described as unworldly, bound up with itself entirely, creating a dream-world, an alternative universe or space where the pleasures of visual and other forms of art could justify themselves by themselves alone. How were he and his generation of artists to reconcile these apparent opposites? This is the theme of these paintings and the reason for their melancholy.

It was with these concerns in mind that, in 1869, Burne-Jones began another series that was to preoccupy him, on and off, for almost the remainder of his career. Beginning in 1869–71, he produced a complex series of paintings on the theme of the Sleeping Beauty story (figs.31–2). The Burne-Jones scholars Stephen Wildman and John Christian suggest that, although there is no written evidence of Burne-Jones's intentions in painting this series, 'contemporary commentators did see in them a religious, even political significance'.[13] They cite an account of the pictures by the French critic Robert de la Sizeranne, who wrote of their meaning:

> The most righteous cause, the truest ideas, the most necessary
> reforms, cannot rise triumphant, however bravely we may fight for
> them, before the time fixed by the mysterious decree of the Higher

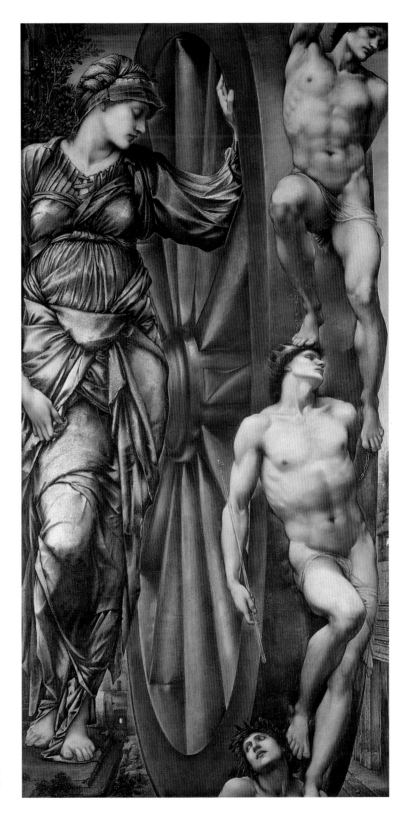

30 *The Wheel of Fortune* 1875–83
[*La Roue de la Fortune*]
Oil on canvas
199 × 100 (78 × 39)
Réunion des Musées
Nationaux

Powers ... The strongest and wisest fail. They exhaust themselves with battling against the ignorance and meanness of their generation, which hem in and hamper them like the branches of the briar rose; and at last they fall asleep in the thorny thicket, like the five knights, who were as valiant as their successor, but who came before their time.[14]

Sizeranne wrote of Burne-Jones in similar terms on several occasions. He saw clearly, as he does in this account of the *Briar Rose* series as political allegory, that Burne-Jones was wrestling with the problems of the effectiveness of art in the world and that he longed for his art to be able to make a difference, to change and transform the lives of his spectators through the character of the works themselves.

On the face of it nothing less like a worldly theme could be imagined. The Sleeping Beauty story tells of the princess who is made the victim of an evil fairy and, pricking her finger, falls into a prolonged sleep with all her father's court sleeping around her. Knights try and fail to rouse her, each in turn succumbing to the enervating pulse of the spell's power, until finally the true prince forces his way into the rose bower where she lies and rouses her with a kiss. *The Briar Rose: The Briar Wood* (1871–3; fig. 31) shows the prince pushing his way through the tangled coils of briar towards the princess, a scatter of less forceful predecessors littering the ground before him, their shields sucked into the impenetrable wall of briar through which he has to find a path. As he steps into the clearing, the prince is on guard, vividly alert, every muscle and nerve straining in case of attack, although he seems not to notice that the briar has already seized his left leg. It is an ambiguous moment: is he emerging from the thicket or being dragged down into it? Is he an idea whose time has come or another hopeful impulse to action whose promise will be smothered before it can be effective?

Perhaps Burne-Jones's solutions to these unanswerable questions lie in sleep itself. Sleep, like other images of enervation, is also an image of the

31 *The Briar Rose:*
The Briar Wood
1871–3
Oil on canvas
60 × 127.5
(23½ × 50¼)
Museo de Arte de
Ponce, The Luis A
Ferré Foundation,
Inc., Puerto Rico

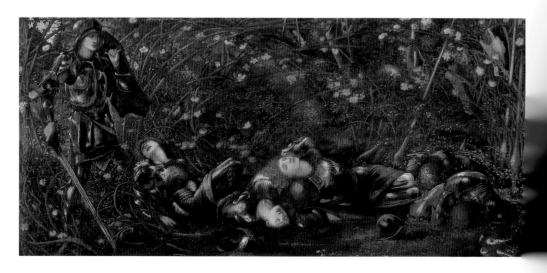

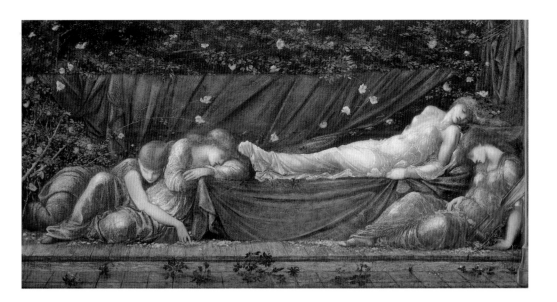

32 *The Briar Rose:*
The Rose Bower 1871
Oil on canvas
60 × 127.5
(23½ × 50¼)
Museo de Arte de
Ponce, The Luis A
Ferré Foundation,
Inc., Puerto Rico

opposite of activity. The figures in *The Briar Rose: The Rose Bower* (1871; fig. 32) are, like those of the knights, in a state which renders them both evocative and beautiful, yet incapable of action. The roses grow down into their presence, slipping over the thigh of the figure at the farthest left, and threatening the head of her nearest companion and that of the princess on the other side of the canvas; the weeds grow through the paving slabs where no one now walks. Stillness, in the shape of the fallen rose petals, invades the world of activity and stops it. There is no action because the spell of beauty, preserved, incorruptible, persisting, stills the engine of the world. We are promised that the prince will wake it up once more, but we are not shown that moment. For the present, it is a field of potential, promise, possibility. Beauty and art can perhaps act in the world, but Burne-Jones cannot tell us how: it is an aspiration, a worrying desire, that is not secure enough to be given any image but that of his longing for it to be true.

These 'seven blissfullest years' of Burne-Jones, then, are complex ones. The burst of creative energy which followed the trip to Italy in 1871 and his liberation from both Maria Zambaco and the demands of the public which followed the Old Water-Colour Society debacle, had its darker side. He was still committed to the ideals which Tractarianism, Carlyle and Ruskin had helped to inspire in him as a young man, but the possibility of realising them through the agency of painting now seemed perpetually to recede, to darken, or to threaten failure the more closely his power and forcefulness as an artist allowed him to approach to them. He was creating works with technical verve and authority, and with a distinctive and individual set of themes, but could these paintings make a difference? Could he make dazzle and affect, make 'people ... see them and say Oh!'? Fundamentally, could he justify his ambitions? Perhaps, after seven years of labour, it was time to return to the public fray.

3

THE GROSVENOR GALLERY
AND FAME

The opening in May 1877 of the Grosvenor Gallery in New Bond Street, London, amounted to a public statement that what a contemporary called the 'Advanced Art' of Rossetti, Burne-Jones, G.F. Watts and others had achieved a measure of recognition.[1] This art was understood to be 'Aesthetic', dedicated to the ideal of 'art for art's sake', or as the critic Sidney Colvin put it, an art that 'addresses itself directly to the sense of sight; to the emotions and the intellect only indirectly, through the medium of the sense of sight', so that it was proof of the fact that 'perfection of forms and colours – beauty, in a word – should be the prime object of pictorial art'.[2]

Founded by the entrepreneur Sir Coutts Lindsay and his wife, Lady Blanche, the Grosvenor Gallery became the temple, the 'Palace of Art', of this emergent cult of Aesthetic beauty for the new audiences who responded to the sensual and contemplative art of Burne-Jones and his fellow artists. 'The great masters who are living some generations in advance of their time sent their pictures to it', the *New York Tribune* told its readers.[3] The first exhibition – in which Burne-Jones's paintings were separated from Whistler's by those of Moore, Watts's *Love and Death* hung immediately next to works by Alma-Tadema, and Leighton occupied an adjacent room – brought together 'the paintings that epitomized the values of "Art for art's sake"', and presented them 'to a wide audience for the first time'.[4]

The Grosvenor famously established itself by miming the decor and ambience of aristocratic country houses for the new middle classes whom 'the Aesthetic Movement' served. In contrast to the Royal Academy's overcrowded walls, the Grosvenor hung its exhibitions with plenty of space around the paintings, although against a damask background of strong red, and at a level where they were visible to spectators. Each artist's works were also hung together, again in contrast to the Academy's practice of routinely consigning an individual's paintings to different parts of the gallery. Although the Lindsays took great pains not to alienate the Academy or academicians, many of whom exhibited with them over the years, the Grosvenor was primarily 'a palace' of new and 'advanced art'. Graham Robertson remembered that:

> The general effect of the great rooms was most beautiful and quite
> unlike the ordinary picture gallery. It suggested the interior of some
> old Venetian palace, and the pictures, hung well apart from each other
> against dim rich brocades and amongst fine pieces of antique
> furniture, showed to unusual advantage ... One wall was iridescent
> with the plumage of Burne-Jones's angels, one mysteriously blue with

Whistler's nocturnes, one deeply glowing with the great figures of Watts, one softly radiant with the faint, flower-tinted harmonies of Albert Moore.[5]

Burne-Jones had agonised about this return to public exhibition. Since the debacle over *Phyllis and Demophoön* at the Old Water-Colour Society seven years earlier he had lived a productive professional life outside the glare of public scrutiny. Now he worried about his return, predicting that 'the worst will be temporary disgrace' and declaring boldly that 'one needn't read criticism'.[6] Others thought differently: 'prepare to be knocked off your legs' said Rossetti who, while declining to exhibit his own works, was pushing Burne-Jones hard.[7] In the event it was Rossetti who was proved right. Burne-Jones showed *The Mirror of Venus* (1870–6; fig.33), the panels from his *Days of Creation* series (figs.2 and 3) and *The Beguiling of Merlin* (1874–6; fig.34), as well as five figures of such subjects as *Fides*, *Spes* and *Saint George* (fig.35). Their reception was astounding. 'From that day he belonged to the world in a sense that he had never done before,' wrote Georgiana Burne-Jones, 'for his existence became widely known and his name famous.'[8] Henry James, reviewing the show, praised 'his imagination, his fertility of invention, his exquisiteness of work, his remarkable gifts as a colourist'.[9] 'An entire school suddenly seemed to have emerged', write the authors of a recent catalogue, 'overnight he was famous, the star of the Grosvenor and the doyen of Aestheticism in its fully developed form.'[10]

33 *The Mirror of Venus* 1870–6
Oil on canvas
122 × 199.5
(48 × 78½)
Calouste Gulbenkian Museum, Lisbon

This may well be because Burne-Jones was one of those who had been Aesthetic before the 'movement' had been born, and whose art contributed fundamentally to its conception. It was hardly surprising, then, that the themes of his successful 'Aestheticist' paintings continued to reflect Burne-Jones's

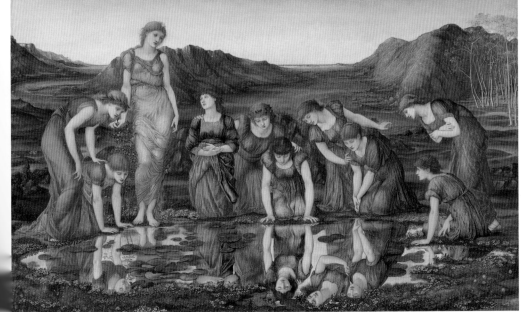

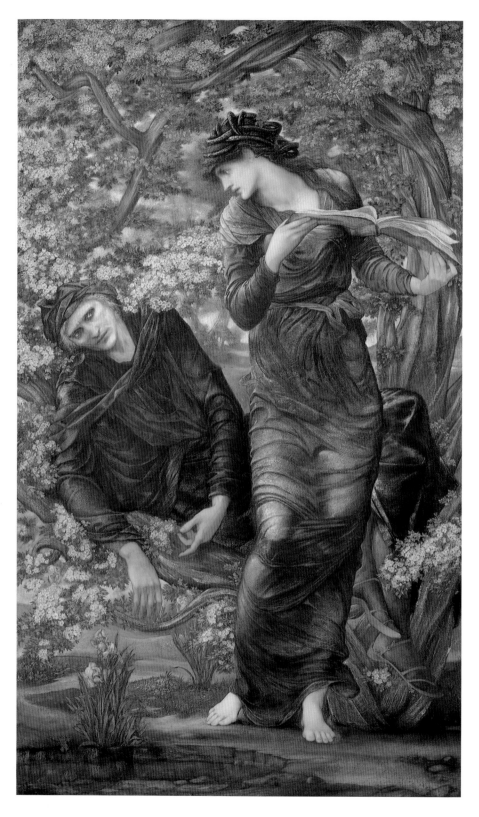

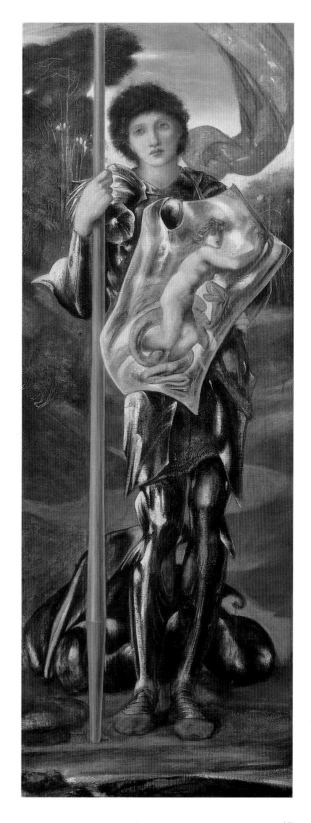

34 *The Beguiling of
Merlin* 1874–6
Oil on canvas
186.2 × 110.5
(73¼ × 43½)
National Museums
Liverpool (Lady
Lever Art Gallery)

35 *Saint George*
1877
Oil on canvas
61.75 × 22.25
(24¼ × 8¾)
Wadsworth
Athenaeum,
Hartford. The Ella
Gallup Sumner and
Mary Catlin Sumner
Collection Fund

preoccupations during the period of his exile. *The Mirror of Venus* evokes a trance state, another version of the sleeping figures in the *Briar Rose* series, spun out of the fascination of the women with their own reflections. They gaze directly into the pool or, in the case of the figure looking upwards and her companion at the far right-hand side, the gaze is mediated through the figure of Venus herself, whose amorous principle defines their contemplation. Set in a version of the north Italian landscape that features in Renaissance art, this is a painting preoccupied with the reference of art to art, art for its own sake, or as its own subject and sole concern. It takes the idea of otherness or absence from the world to a point where action has dwindled to the exchange of glances between meditative worshippers at a shrine.

The Mirror of Venus is perhaps too static an image to be fully compelling. The same cannot be said of *The Beguiling of Merlin*. As in the earlier *Merlin and Nimue* (1861; fig.15), the painting shows the moment when Nimue, or Viviane as she is called here (since Burne-Jones is now using a French source), betrays Merlin, binding him with his own sorcery into a hawthorn tree for eternity. The painting shows the process of weaving the spell, with Merlin sinking slowly into the hawthorn and Viviane chanting from the book of magic in her hands. Merlin is shown at the moment of powerlessness, when the spell begins to work: his head and hands loll weakly, he is entirely supported by the hawthorn tree, enervated and without force. The skin of his face is like parchment stretched over the bone, so that he looks almost on the point of death. Only his eyes, fixed on Viviane, are active. She seems to squirm away from him, powerless though he is, almost teasingly but entirely in earnest, her eyes looking back at him even as she declaims the words from her book.

The Beguiling of Merlin has often been given a biographical interpretation, reflecting Burne-Jones's claustrophobic relationship with Maria Zambaco, and the helplessness of desire clearly is a key element in the painting. As Viviane chants the words that bind Merlin into his magical prison, leeching the strength out of him, she subjects him to the powerlessness of a trance or the unconsciousness of sleep. But, importantly, this enfeeblement now becomes the confirmation of power. Whereas Christine Poulson interprets Merlin's pose as the 'helpless surrender' associated with an hypnotic state, and links it directly with the idea of Burne-Jones's surrender to erotic turmoil in his relationship with Maria Zambaco, in fact this debility and languor stand for the positive status of art in the world.[11] It is precisely because art opts out of the world of action that it is potent, and the power it wields enables it to take charge of and create the world in its own reality, on canvas. The flowing brushstrokes and the flattened, unrealistic space of the boughs, blossoms and draperies accordingly blur the distinction between colour and what it describes. In the material medium of paint and the articulate, descriptive brushstrokes that make up the painting, Merlin's incapacity in the physical realm makes possible his potency in that of art. Art can be the world in its passive contemplation of its own realities, and that meditative focus guarantees its ultimate capacity to affect and change the circumstances it records.

In keeping with hopes like these for the efficacy of art, Burne-Jones talked about his own work as offering a different and more valid access to reality than

36 *Laus Veneris*
1873–8
Oil on canvas
122 × 183 (48 × 72)
The Laing Art Gallery, Tyne and Wear Museums

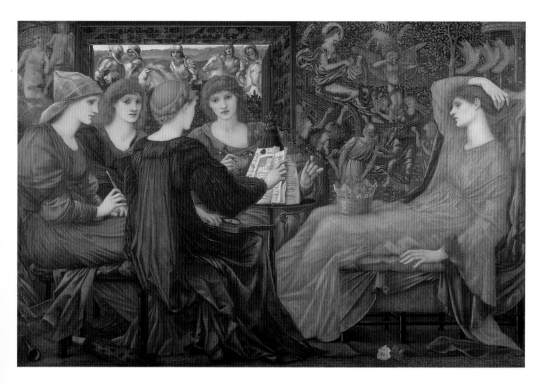

the materialist 'realism' of his time:

> Realism? Direct transcription from Nature? I suppose that by the time
> the 'photographic artist' can give us all the colours as correctly as the
> shapes, people will begin to find out that the realism they talk about
> isn't art at all but science ... Some one will have succeeded in making a
> reflection in a looking-glass permanent under certain conditions.
> What has that to do with art? ... Transcripts of Nature ... What do I
> want with transcripts? I prefer her own signature; I don't want
> forgeries more or less skilful.[12]

Burne-Jones thought of a painting as a 'decorated surface', and commentators such as Henry James saw from an early stage that he introduced spatial and material oddities into his works that were sufficiently striking to be worthy of comment.[13] Writing about *Laus Veneris* (fig.36) when it was first exhibited, James clarified what he meant:

> the fault I should be inclined to charge upon Mr Burne-Jones's figures
> is that they are too flat, that they exist too exclusively in surface.
> Extremely studied and filled in outline, they often strike one as vague
> in modelling – wanting in relief and in the power to detach
> themselves.[14]

James's objection derives from Burne-Jones's flatness and shallowness of space. Robert de la Sizeranne also commented on this, identifying Burne-Jones's application of paint with a more general English tendency in technique. He described the 'English method' thus:

heavy, trivial, laboured, dry, limited, in thick, close touches, *tight*; the labour is apparent, the constraint is surmised, the pains taken by the painter are felt by the spectator. You might be looking at a tapestry woven with infinite pains in exile, by a philosopher or a mathematician.[15]

Burne-Jones's surfaces are heavily worked in this way, the crust of the paint which has been applied in dry, multiple touches is entirely unrepresentative of its subject: surfaces are reduced in the application of paint to variations in a rough, plasterwork texture. T.M. Rooke, Burne-Jones's studio assistant, commented on his medium: 'dreading the darkening of oil and disliking its greasiness, he liked a stiff pigment of the texture of soft cheese'.[16] All this gives the character of the paint surface a peculiar prominence in Burne-Jones's paintings. Its refusal to mimic the textures of the world it depicts redirects attention towards the painting's own constitution as substance, as matter and flat, fictive surface. 'I don't want to pretend this isn't a picture', Burne-Jones declared during a discussion of realism.[17] Surface was one way of emphasising this conviction, by giving the visual character of paint itself a particular importance.

These characteristics are very strongly present in the great *Laus Veneris* of 1873–8 (fig. 36) which was exhibited at the second Grosvenor Gallery show in 1878 where it was widely noticed as a painting requiring contemplation 'inch by inch'.[18] Its subject is connected to a poem of the same title by Swinburne, whose *Poems and Ballads* of 1866 was dedicated 'to my friend Edward Burne-Jones'. Swinburne's poem obsessively investigates the spiritual agonies of the renegade knight of the Tannhäuser legend who, falling under the spell of Venus, abandons morality and salvation for the fatal pleasures of sensuality. Burne-Jones's version is less frenetic, cooler than the overheated eroticism of Swinburne's verse, while sharing its sense of menace and fatality: 'To have known love, how bitter a thing it is, / And afterward be cast out of God's sight'.[19] The sense of imminent action is conveyed in the hot vibrancy of Venus's dress, the compressed, flattened space in which she sits, and the poised, receptive glances of her companions. When they start to play the world will begin to turn again. But for now nothing happens. What we have instead of action is the interplay of visual elements – colour, form and surface texture – displayed across the canvas. This is a painting in which narrative action has been suspended so that the eyes can have their moment. Thus the physical elements of the painting have become the theme and active players. Venus herself represents inactivity, a languishing, powerless version of the sleeping or unconscious figures that populate so many other canvases by Burne-Jones. In contrast, the paint is vigorously active, dense and manipulated in novel ways. Burne-Jones has achieved the effect of Venus's dress and the orange cap worn by one of her companions by taking a punch to the paint and stamping the circular motif into the underpainting throughout the whole length of the painted fabric. The role of achievement and activity in the world has passed from the human protagonists to the very fabric of the image.

Other works by Burne-Jones that share this preoccupation with their own

painterly constitution include *The Perseus Series*, begun in 1875 for the politician Arthur Balfour but never completed, although a full series of cartoons exists. *The Baleful Head* (fig.37) shows Perseus, Andromeda and the head of Medusa. The two protagonists look into a pool of water, the smooth, glassy surface of a well rising to the top of its framing masonry. Here they see the truth that cannot be confronted directly in the world. Contemplating the Medusa's head is contemplating the capacity of imagery to reveal the world to us in ways that are impossible without its reflective capability. *The Perseus*

37 *The Perseus Series: The Baleful Head* 1885
Gouache
153.7 × 129
(60½ × 50¾)
Southampton City Art Gallery

Series as a whole is an account of action related to this theme, but 'action', as the *Times* critic noted in 1888, 'conveyed in a strangely individual way; it is not so much action as the spirit of action'.[20] Commentators agree in finding the series' major quality in its decorative conversion of action into form and colour. *Perseus and the Graiae* (fig.38) has Perseus apparently as blind as the sisters, and even one of the culminating images, Perseus in intense combat with the dragon in *The Doom Fulfilled* (fig.39), makes a static and decorative display of the swirling, interwoven coils of Perseus's antagonist. The *Perseus* series as a whole presents a dialogue between action and contemplation, fixing action into its own stasis where it becomes a subject for meditation. If the relationship between the two poles remains unresolved in *Perseus*, as it does throughout Burne-Jones's work, there is nonetheless a definite sense of the compelling strength in contemplation, in the making of images of things that cannot be properly seen or understood in the midst of the world of action, and of reflection in all its senses as a necessary and productive principle for existence.

The pinnacle of this valuing of reflection and contemplation can be found in Burne-Jones's great work of 1880–4, *King Cophetua and the Beggar Maid* (fig.40). The subject was in the artist's mind as early as 1862, as an oil of the same name in the Tate demonstrates, but the full flowering of its possibilities had to wait another twenty years, when the major themes of his maturity were fully established. Burne-Jones was acquainted with Tennyson's short poem 'The Beggar Maid' (1842) and the Elizabethan ballad from which it was derived, which set out the narrative. King Cophetua, who usually has no time for women, finds himself overcome at the sight of a young beggar whom he resolves to marry and love forever. Burne-Jones chooses the moment when, after bringing the beggar maid to his palace, Cophetua gives himself up entirely to contemplation of her beauty. Seated on luxurious cushions amidst the opulence of the palace, the maid herself looks stunned and anxious, unsurprisingly enough, while the king, who has taken off his elaborate, bejewelled crown in a gesture of submission and seated himself on the steps below her, terrifies her with his besotted gaze.

When Burne-Jones had shown *Laus Veneris* at the Grosvenor Gallery in 1878 he provoked some violent denunciations objecting to the lassitude and decadence shown by Venus as the prime example of the 'unhealthy type with which his work has familiarised us'. Venus appeared 'wan and death-like, so stricken with disease of the soul, so eaten up and gnawed away with disappointment and desire ... The type is to many an offensive, to most a disagreeable one ... The very body is unpleasant and uncomely, and the soul behind it ... ghastly'.[21] His association with Swinburne confirmed these accusations of 'unhealthiness' and 'uncleanness', since Swinburne, like Rossetti himself, was a notoriously decadent exponent of the 'Fleshly School of Poetry'. But *King Cophetua* garnered a completely different set of responses when it, too, was shown at the Grosvenor in 1884. 'It is the idea, the inspiration of this picture which makes it so fine, and raises it to the level of the great masters of a bye-gone age', wrote the *Art Journal* critic.[22] Burne-Jones had, in other words, apparently changed the nature of his work and now drew praise

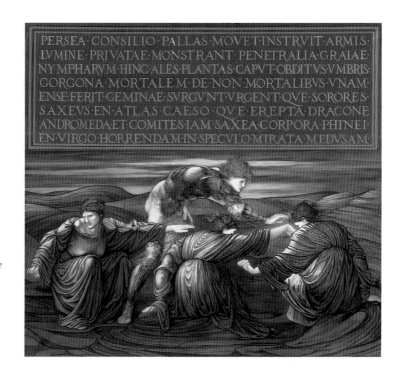

PERSEA · CONSILIO · PALLAS · MOVET · INSTRVIT · ARMIS ·
LVMINE · PRIVATAE · MONSTRANT · PENETRALIA · GRAIAE ·
NYMPHARVM · HINC · ALES · PLANTAS · CAPVT · OBDITVS · VMBRIS ·
GORGONA · MORTALEM · DE · NON · MORTALIBVS · VNAM ·
ENSE · FERIT · GEMINAE · SVRGVNT · VRGENT · QVE · SORORES ·
SAXEVS · EN · ATLAS · CAESO · QVE · EREPTA · DRACONE ·
ANDROMEDA · ET · COMITES · IAM · SAXEA · CORPORA · PHINEI ·
EN · VIRGO · HORRENDAM · IN · SPECVLO · MIRATA · MEDVSAM ·

38 *The Perseus
Series: Perseus and the
Graiae c.1877–80 /
[c.1876]*
Gouache
152.5 × 170
(60 × 66⅞)
Southampton City
Art Gallery

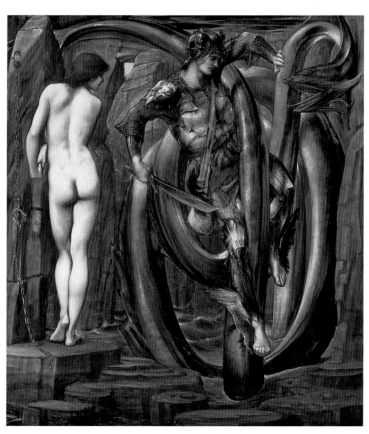

39 *The Perseus
Series: The Doom
Fulfilled c.1884–5*
Bodycolour
153.8 × 138.4
(60½ × 54½)
Southampton City
Art Gallery

for the quality of his draughtsmanship and staunch espousal of noble senti-
ments. This was, for *The Times*, 'not only the finest work that Mr Burne-Jones
has ever painted, but one of the finest ever painted by an Englishman'.[23]

Such responses follow the movement in Burne-Jones's work from an
inactive image of contemplation to an active one. *Cophetua* is every bit as
decorative and abstracted as *The Beguiling of Merlin*, *Laus Veneris* or the *Perseus*
pictures. The apparent depth of the interior balustrade, itself an image of
decoration and visual opulence, is offset by the extraordinary effect of the
lance and shield on the right which flatten themselves up against the surface
of the painting and collapse the entire space into a shallow plane. Every inch
of the painting is decorated and elaborate. Even the maid's dress gave Burne-
Jones endless trouble in his search for something which looked suitably ragged
and at the same time 'as if she deserved to have it made of cloth of gold and set
with pearls'.[24] But despite this confident declaration of the value of the
visual, Cophetua is not simply lost in some shallow or profound dream of his
own satisfaction: unlike the Venus of *Laus Veneris*, he has enough energy and
initiative to go out into the world and seize some part of it to bring back into
the private space where he can contemplate it. The maid symbolises the world;
the king's gaze, fixed on her with a mixture of desire and veneration, repre-
sents the meditative gaze of the artist or spectator, productive where action
would reveal nothing. The circuit of their visual dialogue is the conversion of
the things of the world into an image, a form in which they may be considered
and gradually understood.

The implications of this were not lost on Burne-Jones's commentators.
Robert de Sizeranne connected the *mise en scène* of the painting and its
powerful statement of the values of contemplation to the original driving
forces of Burne-Jones's art. He saw *King Cophetua* at the Exposition Universelle
in Paris in 1889, where it was such a success that Burne-Jones was awarded
the Légion d'honneur:

> It seemed as though we had come forth from the Universal Exhibition
> of wealth to see the symbolical expression of the Scorn of Wealth. All
> round this room were others, where emblems and signs of strength
> and luxury were collected from all the nations of the world – pyramids,
> silvered or gilt, representing the amount of precious metal dug year by
> year out of the earth; palaces and booths containing the most
> sumptuous products of the remotest isles – and here behold a king
> laying his crown at the feet of a beggar-maid for her beauty's sake.[25]

Sizeranne discerned in *King Cophetua* the suspicion of the world of industrial
wealth and creation which the Exposition Universelle was designed to cele-
brate, and which Burne-Jones had learnt to detest as a young man in the Black
Country around Birmingham. Contemplation is the opposite of action, and
action stands not simply for the chaos of activity in the world, but for the rest-
less energy of the West as it exploits the rest of the world for material gain so
single-mindedly and with such disregard for the spiritual values that sustain
the human world. 'We had seen nothing but matter', wrote Sizeranne, 'and
here we had come on the exhibition of the soul.'

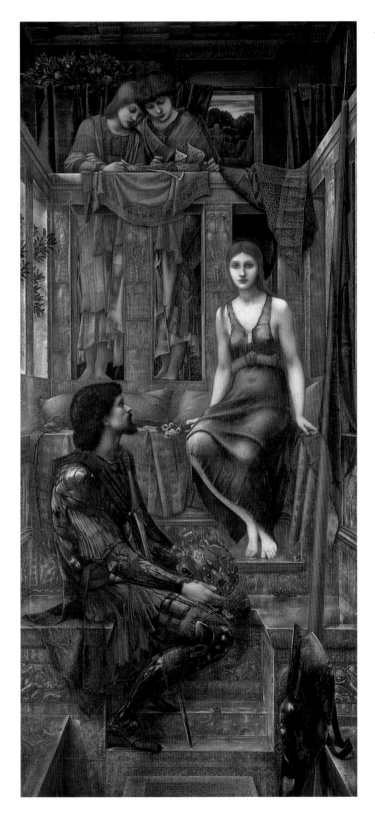

40 *King Cophetua
and the Beggar Maid*
1880–4
Oil on canvas
293.4 × 135.9
(115½ × 53½)
Tate

These things were powerfully at work in Burne-Jones's mind during the early 1880s. In 1882 he finally completed *The Mill* (fig.41), on which he had been working off and on since 1870. Penelope Fitzgerald sees in its evocation of old technology in the midst of a rural environment, in front of which three women perform a slow, stately dance, a reflection of Ruskin's alternative to industrial technology, his 'dreams of the Society of St George', 'where wind and water would be the only motive power' and steam and modernity are equally abjured.[26] It is, in short, a celebration of the spiritual values Burne-Jones most prized, of love and supportive emotional intimacy – the three women include Burne-Jones's friends Marie Spartali and Aglaia Coronio, as well as Mary Zambaco – all set against the modern world.

But for Burne-Jones these values importantly remained contemplative and could not and should not be translated into action. It was contemplation – the passivity of Merlin before the active world – that guaranteed the truth and authenticity of the values promoted by art. As soon as art threatened to act, even actively to influence the world, it would fail, become corrupted by the mechanistic values it sought to oppose. Tellingly, this moment of clarification of a Ruskinian attitude to wealth, materialism and spiritual value in Burne-Jones's paintings of the early 1880s was also the point at which William Morris's increasing conviction of the necessity of an active socialist solution to the modern world began to harden, and it led to a near rift between the two old friends. By 1883 Morris was selling his books and paintings in order to give financial support to the socialist Democratic Federation, and he was recommending active political solutions to the problems of the industrial age. His was another, equally legitimate extrapolation of the Ruskinian inheritance, but not one that Burne-Jones was either temperamentally or spiritually prepared to accept. 'We are silent about many things', he wrote about the increasingly awkward meetings of the two men, 'and we used to be silent about nothing.'[27]

This rift was the source of considerable grief for Burne-Jones over the next few years. But he stuck to his principles and, perhaps under the pressure which this development brought with it, increasingly clarified his belief in the power of contemplative art, of spiritual truth in which glowing colours and stirring, evocative forms could do as much as Morris's political marches and thundering denunciations from the platform to compensate for the rule of

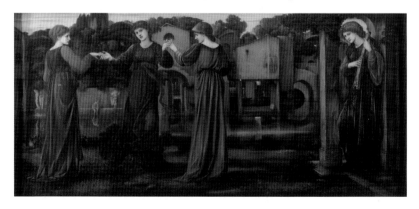

41 *The Mill*
1870–82
Oil on canvas
90.8 × 197.5
(35¾ × 77¾)
Victoria & Albert
Museum, London

42 *Georgiana Burne-Jones* 1883
Oil on canvas
73.7 × 53.3
(29 × 21)
Private collection

materialism and the machine. His portraits of his wife Georgiana (fig.42) and daughter Margaret (fig.43), to whom he was very close at this time, offer another version of these values. Georgiana sits in front of her two children; Margaret is posed before a convex mirror which reflects the internal world of the home and domesticity. Both are serene, poised, principles of strength and stability in a complex world.

In keeping with this increasing inwardness, Burne-Jones once again contrived a situation in which it became impossible for him to continue as a member of the establishment or to lead a comfortable life in the public gaze. In 1885, when he was elected as an Associate of the Royal Academy of Arts, he instantly began to chafe against the bit of conformity. He only ever showed

43 *Margaret Burne-Jones* 1885–6
Oil on canvas
96.5 × 71.1
(38 × 28)
Private collection

one picture there, *The Depths of the Sea* (1886; fig.44), exhibited the following year. A grimly macabre picture, with the triumphant mermaid dragging the body of her lifeless victim down to the seabed littered with vast marine architecture, its ghastly eroticism seemed to mark a return to the disturbing implications and the listless and corrupted Venus of *Laus Veneris*. The picture so disquieted both commentators and academicians, although they tried to be respectful, that Burne-Jones felt vindicated in his conviction that he could never be a proper member of the Academy and that he should never exhibit there again. Success had not mitigated his loneliness and sense of difference: he was an unassailably important figure in British art by the late 1880s, but one who insisted on occupying that place largely on his own terms.

44 *The Depths of the Sea* 1886
Oil on canvas
197 × 75
(77½ × 29½)
Private collection.
Courtesy of Julian
Hartnoll

4

AVALON

In her biography of Burne-Jones Penelope Fitzgerald gives the following figures raised at the sale of the collection of the shipowner Frederick Leyland. Leyland, who died in 1893, had been a supporter and patron of both Whistler and Burne-Jones, as well as a notable collector of other contemporary and Old Master art. At the sale Whistler's great *Princesse du Pays de Porcelaine* (1863–4) went for 420 guineas, some Botticelli illustrations to Boccaccio for 1,300 guineas, and Burne-Jones's *The Beguiling of Merlin* for 3,600 guineas.[1] It is a measure of Burne-Jones's success in the 1890s (as well as of Whistler's shaky reputation: he was never to forgive Burne-Jones for this imbalance) that the bidding for the *Merlin* was started at 1,000 guineas. In 1894, and to some degree against his better judgement, Burne-Jones became a baronet for his services to art. But none of this made Burne-Jones any happier: he continued in the self-deprecating gloom that had characterised the somewhat self-dramatising image he had presented of himself during the previous two decades. Whether claiming he was aged 175 or writing to his friend Frances Horner that 'pain is the shadow of happiness – the deeper it is the brighter is the light', he was sunk, not entirely without pleasure, in the melancholy substitution of hope for fulfilment.[2]

It was at this time that his earlier conviction that art should have a purpose and an effect, should change the world or better the lives of its audience, underwent a significant shift in tone. While he never entirely lost the reserve of energy and determination that allowed him to manage his career with such success, towards the end of his life he became more genuinely inward in both his life and his art than he had truly been before. 'He seemed now to live more and more within himself', commented Georgiana, and he rarely agreed to any public appearance.[3] After the abortive exhibition of *The Depths of the Sea* (fig.44) at the Royal Academy he was determined not to pursue his public life, and he spent more and more time at the house in Rottingdean in East Sussex which he had bought in 1880. He perhaps sympathised with Danae waiting to be shut up in her own space in *The Tower of Brass* (1888; fig.45), contemplating, from the safety of the cloak with its lovely colours which she winds around herself, her vanishing away from the world, or with Merlin's fate in his paintings of the wizard's beguiling. Burne-Jones found a focus for this inwardness in a renewed meditation on the figure of the artist and on his capacities and powers. 'I need nothing but my hands and my brain to fashion myself a world to live in that nothing can disturb', Georgiana remembered him saying at this time, 'in my own land I am king of it.'[4]

A number of paintings made during the nineties echo and explore these themes. Burne-Jones imagines himself as *The Wizard* (1891–8; fig.46), like

45 *The Tower of Brass* 1888
Oil on canvas
231.1 × 113
(91 × 44½)
Glasgow Museums:
Art Gallery &
Museum,
Kelvingrove

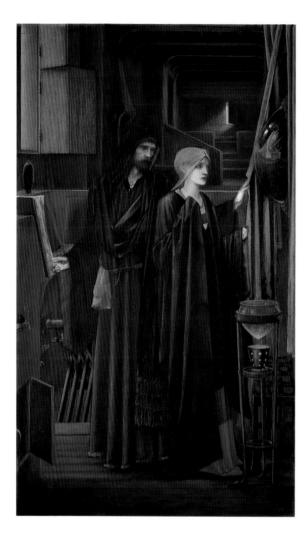

46 *The Wizard*
1891–8
Oil on canvas
91.5 × 54
(36 × 21¼)
Birmingham
Museums & Art
Gallery

Prospero in *The Tempest* showing a young girl (who has the face of Frances Horner) the image of a shipwreck in a convex mirror. The collapsed face and parchment-like skin of this magus, surrounded by the instruments of his arcane craft, shut away with only the thinnest ray of natural light breaking through the shutters and immediately dying into the silent atmosphere, reflect Burne-Jones's own image of himself. He is exhausted but also, within the enclosed room of his imagination, powerful. Hollowed out by struggle and effort, he can still spin magic out of the earth, the substance of his pigments themselves and the base material of his art – for he is, as Burne-Jones said of the wizard, the 'necromancer', who raises the dead from the dust into which they have fallen.[5] The master of a dark craft, he is able to fascinate through the images he conjures up, although his resurrections are confined to a shadow in a mirror and are perhaps doomed to failure.

As Stephen Wildman and John Christian note, Burne-Jones's convex mirror recalls Jan van Eyck's *Portrait of Giovanni Arnolfini and His Wife* (1434; fig.47) which, entering the National Gallery in 1842, had an enormous

impact on the Pre-Raphaelites and their successors. At this time Burne-Jones was thinking back to his first encounter with the picture, confessing that he had always wanted 'to do a picture like a Van Eyck and I've *never never* done it, and never shall ... and now the time's gone by'. He looked hard at the painting in 1897 when he was completing *The Wizard* and knew now 'how clearly the like of it is not to be done by me'.[6] The ambitions of Burne-Jones's youth and middle age were now finally expunged: he would never be able to make of his art the instrument he craved. The convex surface of the mirror, thrusting into the real space of the world, remains an impermeable skin between reality and art, showing only dust and shadows although it fascinates more than the man of flesh and blood who, ignored, reveals it to the desired spectator. *The Wizard* is accordingly a complicated image, dominated by regret and uncertainty. 'I

47 Jan van Eyck
The Portrait of Giovanni(?) Arnolfini and his Wife Giovanna Cenami(?) ('The Arnolfini Marriage')
1434
Oil on wood
81.8 × 59.7
(32¼ × 23½)
National Gallery, London

ought to forget there is a world', said Burne-Jones, provoked by thinking about this painting, 'I ought to behave as if there weren't such a thing as the world existing at all.'[7] Is the power wielded by painting ever enough, or is it a hollow form, outside real life and irrelevant to it?

As part of a familiar return in old age to the interests and enthusiasms of youth, Burne-Jones again took up the story of Arthur and the cycle of stories of which he is a part. In keeping with his own mood and concerns, Burne-Jones now found most compelling not the heroic stories of chivalry and glory, of active life in the world, but their dark negative, those parts of the cycle concerning death and failure, the introspection that is the product of frustrated action. *The Dream of Launcelot at the Chapel of the San Graal* (1895–6; fig.48) takes up one such moment, when the flawed hero Launcelot has become another exhausted figure whose power is expunged. Everything is dark except the silvery light that shines along the length of Launcelot's body and is picked up and flattened in the angel of his dream and the illumination from within the chapel. 'Hard to get colour into it because of the night – or the knight', joked Burne-Jones, but the equivalence is real.[8] The subject here is failure – of ambition, principle and morality, of action in all its forms. Launcelot lies with his sword slipping from his hand and his shield hanging 'on a withered tree, symbolising the failure of his ambitions', and although the angel of the dream promises some redemptive hope, it is the moment of powerlessness and lassitude under the weight of failure that concerns Burne-Jones.[9] Although he made a painting of *Hope* at this time (fig.49), in fact closely based on an older design of 1871 for some stained glass, he took care to show her chained. 'Hope is a mere luxury, not a necessity', he said, 'the fortunate may safely indulge in it.'[10]

48 *The Dream of Launcelot at the Chapel of the San Graal* 1895–6
Oil on canvas
138.5 × 169
(54½ × 66½)
Southampton City
Art Gallery

49 *Hope* 1896
Oil on canvas
179 × 63.5
(70½ × 25)
Museum of Fine
Arts, Boston. Given
in memory of Mrs
George Marston
Whitin by her four
daughters, Mrs
Lawrence Murray
Keeler, Mrs Sydney
Russell Mason, Mrs
Elijah Kent Swift and
Mrs William Carey
Crane

Hope also features in the painting *Love and the Pilgrim* (1896–7; fig.50), which forms the final image of a series based on Chaucer's *Romance of the Rose*. Burne-Jones's double here is the stooped pilgrim, torn by thorns and still half tangled in them as he steps gingerly out to clear ground with the aid of Love, whose wings are surrounded by a moving flock of birds, symbols of liberation and free flight. The tonalities of this painting are both sombre and delicate; the figure of Love is clothed in a shining, silvery light providing a picture of hope and release both positive (the foot of Love striding away into freedom) and steely cold. If this is liberation, the landscape is no less bleak and the prospect perhaps no less dark than in the similarly shimmering light of *The Dream of Launcelot*. When he showed the painting at the New Gallery in 1897, Burne-Jones placed two lines from Swinburne's 'Tristram of Lyonesse' (1882) in the catalogue: 'Love that is first and last of all things made / The light that morning has man's life for shade'.[11] The characteristically knotty syntax of the second line, miming the confusion of hope and despair or rather despair-in-hope that Burne-Jones seems to feel, catches the tone of the painting very precisely. Is it 'light' or 'shade' that is emphasised? It is 'shade', which comes last in Swinburne's line, after all, and the sombre nature of 'man's life' that is more truly felt here than hope.

A similar mixture of emotions in which despair is again the dominant partner appears in *The Car of Love* (fig.51), begun in the 1870s and left unfinished twenty years later. Here the energy of the swirling black draperies cannot disguise the fact that everyone is bound, oppressed, and coerced by 'Love'. The massive wheels of the chariot are rolling like Juggernaut to crush the helpless worshippers who struggle uselessly to outpace their fate.

The most significant of the Arthurian paintings is *The Sleep of Arthur in Avalon* (fig.52), which Burne-Jones worked on intermittently between 1881 and 1898. This large canvas (281.9 × 645.2 cm /111 × 254 in) has been described as Burne-Jones's 'masterpiece', the final melding together of the

50 *Love and the Pilgrim* 1896–7
Oil on canvas
157.5 × 304.8
(62 × 120)
Tate

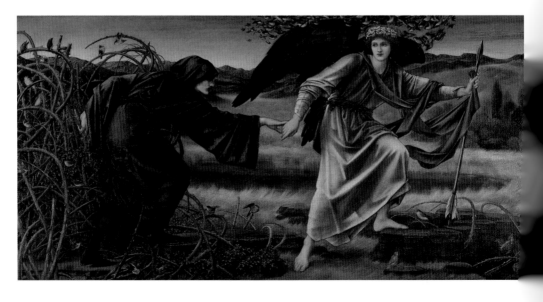

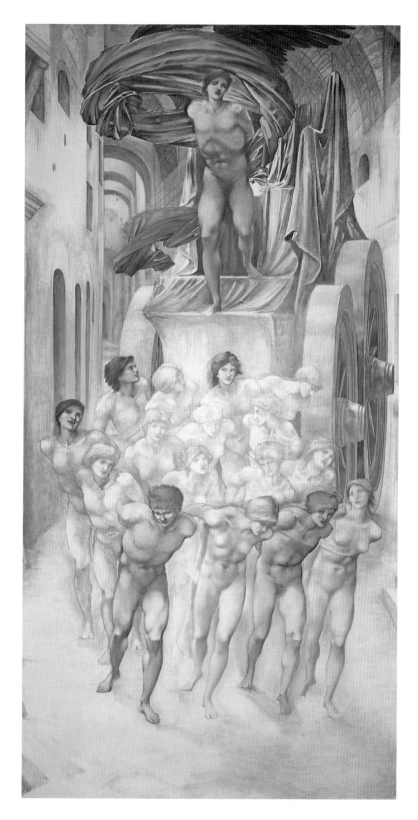

51 *The Car of Love*
begun 1872
Oil on canvas
518.2 × 273.1
(204 × 107½)
Victoria & Albert
Museum, London

artist and 'the world of his imagination'.[12] But one might think it less than successful, or that the identity of the artist and his imagination is a darker thing than might be assumed. Burne-Jones paints himself into the scene in the figure of Arthur (he would apparently sometimes sleep in that position himself, although the model for the head was William Morris), at one of the climactic moments of the cycle, when the wounded and dying king is carried off to the magical island of Avalon to be preserved forever, uncorrupted but asleep. It is, in its way, a dream of ultimate inaction, giving final expression to Burne-Jones's anxiety about the capacity of art to affect the world and the gradual dwindling of his own powers of tolerance for activity as he grew older. Arthur's heroism, his status as a beacon of hope and a guarantee of physical safety for England down the centuries, depends on his silence and inactivity, his withdrawal from the world into a mythic and dreamlike abstraction. Like Burne-Jones, he is king 'in my own land', but his sovereignty is death. 'I do hate a Necropolis', joked Burne-Jones; but that is what he made.

It is perhaps this sense of despair, or of a wearied capitulation to an inevitable defeat, that makes this painting so unsatisfactory. For a picture predicated upon the idea of inaction it consumed a huge amount of the artist's active energy as he revised and altered the canvas and design over the seventeen years of the painting's studio history. Watching spectators were inserted and removed, the sea appeared and was then dispensed with, Arthur's attendants came and went. He was still working on the painting the day before he died. When he wasn't actively painting he was making sketches, studies and drawings towards the project. It would never satisfy him. Perhaps, even, it was the relentless work that never reached fulfilment that appealed to Burne-Jones: it was an image of his unfulfilled desire. The final state of the picture is accordingly a compromise, and its long history of alter-ations and revisions has given it something of the flavour of a painting made by a committee. It lacks the movement and suggestiveness that gives so much of Burne-Jones's work its vitality, so that the final effect is pious and dull.

But painting was not the only medium in which Burne-Jones worked in this last phase of his career. At the end of their lives Burne-Jones and William

52 *The Sleep of Arthur in Avalon* 1881–98 Oil on canvas 281.9 × 645.2 (111 × 254) Museo de Arte de Ponce, The Luis A. Ferré Foundation, Inc. Ponce, Puerto Rico

Morris were reconciled and returned to the enthusiasms and ambitions of their youth. They planned to launch Morris's fine art Kelmscott Press (1891) with a collaborative edition of Chaucer, whom they had loved since they began to read to each other at Oxford, and to make 'at the end of our days the very thing we would have made then if we could'.[14] The edition, published in 1896 after much delay on Burne-Jones's part, with an eventual total of eighty-seven designs, was a great success (fig.53). The design of the publication is carefully integrated, the illustrations and text matching to 'form the most harmonious decoration possible to the printed book', as Morris put it.[15] It is a fitting testament to the lifelong enthusiasm and shared passions of the two friends.

Morris's Firm and his design activities gave Burne-Jones other opportunities at this time. The series of Holy Grail tapestries he designed in 1890–1, which were woven between 1891 and 1895, provided Burne-Jones with an additional opportunity to explore the Arthurian cycle and to revisit the medievalism of his work of the 1850s. *Sir Galahad sees The Holy Grail*, another Arthurian subject, was designed between 1880 and 1890 for realisation by Morris & Co. as stained-glass panels for Burne-Jones's Rottingdean house (fig.54). Until the very end of his life Burne-Jones continued to be active as a designer as well as a painter. His creativity found expression in a multitude of ways, and the rigour and fluency of his designs contributed to the success of his furniture, fabric and wall decoration, and stained glass.

53 Title page and first folio from *The Works of Geoffrey Chaucer*, Kelmscott Press 1896 Exeter College, Oxford

how galahad sought the sangreal and found it because his
heart was single so he followed it to sarras the city of the spirit

54 William Morris
and Edward Burne-
Jones
*Sir Galahad sees The
Holy Grail* made by
Morris & Co.
1880–90
Stained-glass panel
Victoria & Albert
Museum, London

The Kelmscott Chaucer was the climax of the two men's extended life
together. Morris was unwell during its final stages and, after an illness, he died
in the autumn of 1896, having lived to see the book published. Burne-Jones
was deeply distressed: he saw the end of his own life presaged, as well as the
extinction of all that he had believed in and fought for. He felt himself newly
at odds with the world, with his works not selling and his labour increasingly
one of inward and personal search for solace and some subtle, precise, resolu-
tion of the mingling of hope and despair in the world. 'I'm sorry for the world',
he said about Morris's death, 'he could well do without it, but the world's the
loser.'[16] Troubles with the family, particularly worries about his weak son,
Philip, general debility and irritation with the world almost visibly ground
him down towards the end of the 1890s. But to the last Burne-Jones was still

amusing and self-mocking in his private drawings and in the dry, laconic wit of his correspondence (fig.55). He died, after a final day wrestling with *The Sleep of Arthur in Avalon*, in June 1898, and was buried in Rottingdean church.

When he died Burne-Jones had some grounds for both exhaustion and despair. He had worked long and hard, with a powerful commitment to the idea of art as a force for good in the world, and at the end had seen his own legacy threatened. His reputation since his death, had he been able to foretell it, would, despite its darker moments, have put his mind at rest. Burne-Jones's eminence during the latter part of his lifetime resulted in a substantial influence on the late Aestheticism of the art shown at the Grosvenor Gallery and its successor, the New Gallery, in the final decades of the nineteenth century. Artists such as John Roddam Spencer Stanhope, John Melhuish Strudwick (fig.56), Walter Crane (fig.57) and Evelyn De Morgan were all indebted to Burne-Jones's example in creating their own visually elaborate versions of the dream-world. When Stanhope, Strudwick and Crane exhibited at the opening show of the Grosvenor, they seemed to a contemporary critic to be 'a school of the highest type', one of which Burne-Jones was the clear leader and senior figure.[17] But he was never either a joiner or a leader, as we have seen, and the concerns of these artists were in reality more varied and individualistic than comments of this sort suggest. The 'school' never materialised or achieved any real group identity. No doubt this was the way that Burne-Jones felt happiest. The aims of his art could not be generalised, even if his associates had been prepared to repeat his achievement, and he remained a magnificent but largely solitary figure on the late-Victorian scene once the brief moment of the first Grosvenor exhibition had passed.

But this is not to say that Burne-Jones had no influence at all. He was an important originator for the precise, high-coloured fictions of Strudwick and the others, works very characteristic of a major, if still rather neglected, strain of English painting in the decades on either side of 1900. In his own time Burne-Jones was a significant voice in the diverse chorus which made up the Aesthetic movement. He had many differences with Whistler, but, in retrospect, it seems clear that Burne-Jones's fascination with the media he made his own, oil paint and watercolour, and his persistent, reflexive interest in the visual vocabulary of painting itself, are analogous to Whistler's near-subjectless paintings with their sweeping brushmarks and approach to abstraction. Like Leighton, Watts, and such other artists as Sir Edward Poynter and Lawrence Alma-Tadema, Burne-Jones also played a role in the revival of a neoclassical sensibility in English painting from the 1860s onwards. His trips to Italy and subsequent revision of his own aesthetics brought him close to this second major strand of English art during his lifetime. Burne-Jones is, in some ways, a protean artistic figure, but one suited to the protean quality of the art world in which he moved and played such an important role.

It was precisely for this reason that Burne-Jones suffered badly when, during the early twentieth century, Victorian art went out of fashion and various versions of modernism began to emerge. It was only in 1895, a very few years after the New Gallery retrospective of 1892 and the phenomenal sales prices recorded at the start of this chapter, that Burne-Jones's works started not to

55 *The Artist Attempting to Join the World of Art with Disastrous Results*
1883
Pen and ink
The British Museum

sell. This is a constant theme of *Burne-Jones Talking*, a publication recording many of the conversations with his studio assistant, Thomas Rooke, which took place between 1895 and the artist's death. 'This is the third year now that my things haven't sold', he told Rooke in 1898, 'shall have to finish *Avalon* and the *Car of Love* without any expectation of selling them'.[18] His old patrons fell away and Burne-Jones found himself increasingly obliged to solicit buyers for his work, although often the hoped-for sale was not forthcoming.

The change in sensibility and taste marked by Roger Fry's two Post-Impressionist exhibitions held in London in 1910 and 1912 had almost no room for art of Burne-Jones's type. Once the emphasis was on 'significant form' (the great phrase of the Bloomsbury aesthetics that flowed from Fry), on colour, line and volume as the essential and only qualities of painting, and on a sense of the modernity of the new twentieth-century world, Burne-Jones's dreamlike subjects made him look hopelessly old-fashioned. In this context

56 John Melhuish
Strudwick
St Cecilia 1897
Oil on canvas
91.5 × 91.5 (36 × 36)
Bennie Gray, London

Burne-Jones's own concerns with the character of painting became invisible and he found himself superseded in the public taste by the more gestural technique of Impressionism during his own lifetime. 'The doctrine of the excellence of unfinished work was necessarily repugnant to Edward,' recalled Georgiana Burne-Jones, 'who was at first incredulous as to its being seriously held by any one; but as what is called the "Impressionist" school gained ground it became one of the most disheartening thoughts of his life.'[19] His arguments with Whistler – against whom he spoke at the Whistler-Ruskin trial – were of this type, Burne-Jones objecting to Whistler's 'unfinished' canvases. This was fundamentally an objection to the lack of significant content in the sort of painting that embraced the abstracting impulse in modernism and concerned itself solely with questions of form. 'I never saw a set of people so destitute of ideas,' said Burne-Jones, 'who are so bent on making painting a stupid art, who constantly justify Byron's cruel saying of it that it is a stupid art.'[20] His own art had always striven to be intelligent, having meaning and content and addressing the realities of the world it encountered. His fascination with the mechanisms through which that meaning was achieved in oil painting arose through dealing with the modern world of Victorian England: it was a concern with the means to the necessary end, and its rules were clarity, legibility and a penetration to the heart of human life.

But Burne-Jones's star was not entirely eclipsed during the rule of modernism. A centenary exhibition was held at the Tate Gallery from June to August 1933, the creation of William Rothenstein and Thomas Rooke. Although the public attended the show, Stephen Wildman and John Christian have been able to assemble a depressingly large collection of contemporary critical reactions which mingle contemptuousness and condescension, and which largely depend on an uncritical acceptance of the modernist doctrine of significant form. 'Best ... enjoyed ... as an artistic dreamer', thought *The Times*, 'and [best not] regarded as in the central tradition of painting, when he is bound to suffer', while the art-historical trade paper *Apollo* thought he 'will not live ... because he accepted an interpretation of "poetry" that glorifies life at second hand. He dealt in the shadows not the substance of art'. 'The tide of feeling against B-J is high', summed up Sydney Cockerell, the director of the Fitzwilliam Museum, who was himself not unsympathetic to the artist.[21]

Despite signs of a minor revival during the years after 1940, which saw the publication of William Gaunt's still widely read *The Pre-Raphaelite Tragedy* in 1942 and the acquisition by the Tate of *Love and the Pilgrim* in the same year, it was not until the 1960s that Burne-Jones came to seem interesting again, in tune with the general rehabilitation of Victorian culture. A new generation, geared to rebellion against the tastes and opinions of the 'modernist' generations of the early twentieth century, was achieving positions of influence in the art world as elsewhere in society, and the Pre-Raphaelites, Victorian art and Burne-Jones all benefited from the desire to recover new, or rather old, pleasures. The art of the period was once again of interest to dealers, although prices remained low. There was a major exhibition of Burne-Jones's work at the Hayward Gallery in 1975, and a series of smaller or group exhibitions continued to bring his work to the public. The final rehabilitation of this great

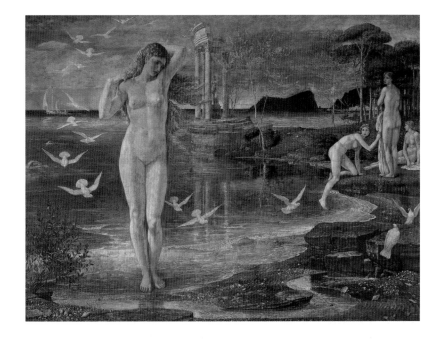

57 Walter Crane
The Renaissance of Venus 1877
Tempera on canvas
138.4 × 184.1
(54½ × 72½)
Tate

Victorian artist was signalled in 1999 when the exhibition *Edward Burne-Jones: Victorian Artist-Dreamer* travelled from Birmingham to the Metropolitan Museum of Art in New York and the Musée d'Orsay in Paris. The unique sight of a British artist being granted this type of international recognition suggests an acknowledged status as a major figure in the central tradition of Western painting.

This seems a just assessment. Burne-Jones's dedication to the world of art, of contemplation and reflection as principles by which to live, and which might be equal or superior to the frantic world of action, continues to speak to audiences today as it did to his contemporaries. His art makes powerful claims for the status and authority of painting as a means of understanding the world and of defining and promoting values that the everyday world rarely has time to recognise. The art historian and curator Robin Ironside, one of the most sensitive of Burne-Jones's mid-twentieth-century supporters, commenting on 'the poetic gravity, the almost suave nostalgia, which distinguish the vision of Burne-Jones', thought 'he did not believe in didactic art ... the spectator is simply asked to share the dream'.[22] It is true that his art does not browbeat or coerce the viewer: he was never one to mount the podium, like his friend Morris, or to thunder and denounce after the fashion of Ruskin. But quietly and persistently, Burne-Jones promotes the values he wishes to set against those of his culture. Art is strong if it provides a mirror, a medium for contemplation and reflection, in which love, friendship, devotion and duty can appear and be promulgated and assessed. If his art also examines that claim and worries about it, then it is even stronger for his scrupulous and intelligent anxiety. The need for a meditative understanding of our lives has not gone away. At the beginning of the twenty-first century, Burne-Jones repays our close attention.

Chronology

I have relied on the very full chronology given in *Edward Burne-Jones: Victorian Artist-Dreamer* (1998) and on the narrative account given in Penelope Fitzgerald, *Edward Burne-Jones* (1975).

1833 Burne-Jones born in Birmingham on 28 August. Death of his mother.

1844–52 King Edward VII School, Birmingham.

1848–52 Government School of Design, Birmingham.

1853 Exeter College, Oxford; meets William Morris.

1854 Begins *Fairy Family* illustrations. Discovers Pre-Raphaelites.

1855 Burne-Jones and Morris discover Malory's *Morte D'Arthur*. The two visit France.

1856 Meets Ruskin and Rossetti; leaves Oxford without a degree and moves to London with Morris. Rossetti's pupil. Rooms at 17 Red Lion Square. Becomes engaged to Georgiana Macdonald, whom he first met in 1851.

1857 Stained-glass designs for James Powell & Sons; first attempts at oil painting. *Fairy Family* published. Decorates the Oxford Union with Rossetti and others.

1858 Meets G.F. Watts at Little Holland House in Kensington. Moves to 24 Russell Place, Fitzroy Square. Pen and ink drawings.

1859 Teaches at Working Men's College. Visits Italy.

1860 Marries Georgiana in Manchester. Stained-glass designs.

1861 Foundation of Morris, Marshall, Faulkner & Co. ('The Firm'). Moves to 62 Great Russell Street. Son, Philip, born.

1862 Visits Italy with Ruskin.

1864 Becomes Associate of the Old Water-Colour Society. A son, Christopher, is born and dies aged 3 weeks.

1865 Begins illustrations for Morris's poem, *The Earthly Paradise*. Moves to 41 Kensington Square. William Graham and Frederick Leyland become patrons.

1866 Birth of daughter, Margaret. Swinburne dedicates his *Poems and Ballads* to Burne-Jones.

1867 Moves to The Grange, North End Lane, Fulham. Relationship with Maria Zambaco.

1869 Thomas Rooke becomes his studio assistant.

1870 *Phyllis and Demophoön* exhibited at the Old Water-Colour Society, where it is severely criticised. Resigns his membership. Ends relationship with Zambaco. Withdraws from most exhibiting and public life.

1871 Visits Italy.

1873 Final visit to Italy.

1875 Re-foundation of The Firm as Morris & Co. Burne-Jones becomes sole stained-glass designer.

1876 Finishes *The Mirror of Venus* and *The Days of Creation*.

1877 Exhibits 8 works at the opening show of the Grosvenor Gallery; extremely positive reception in the press and from the public.

1878 Shows 11 works at the second Grosvenor exhibition, including *Laus Veneris*, *Le Chant d'Amour*. Visits Paris; *The Beguiling of Merlin* shown at the Exposition Universelle, Paris. Gives evidence against Whistler in the Whistler-Ruskin trial.

1879 *Pygmalion and the Image* at the Grosvenor Gallery.

1880 Shows *The Golden Stairs* at the Grosvenor. Buys North End House, Rottingdean, near Brighton.

1881 Honorary doctorate from Oxford University.

1882 Builds his Garden Studio at the Grange.

1883 With Morris, Honorary Fellowship at Exeter College, Oxford. Exhibits stained-glass at The Firm's stand at the Boston Foreign Fair.

1884 Shows *King Cophetua and the Beggar Maid* at the Grosvenor Gallery. Designs window for St Philip's Church in Birmingham (subsequently Birmingham Cathedral).

1885 Elected Associate of the Royal Academy of Arts.

1886 Exhibits *The Depths of the Sea* at the Royal Academy, but never shows there again. Re-elected to the Old Water-Colour Society.

1888 Exhibits at the New Gallery in Regent Street, the successor to the Grosvenor Gallery.

1889 Burne-Jones's father dies. *King Cophetua and the Beggar Maid* shown at the Exposition Universelle in Paris; awarded the cross of the Légion d'honneur.

1890 Shows *Briar Rose* series in London.

1891 Begins the illustrations for the Kelmscott Chaucer.

1892 Elected as corresponding member of the Académie des Beaux-Arts, Paris. Retrospective exhibition at the New Gallery.

1893 Resigns as Associate of the Royal Academy.

1894 Created a baronet by the Prime Minister, William Gladstone.

1896 Kelmscott Chaucer published. Morris dies.

1897 Final designs for the Kelmscott Press.

1898 Dies during the night of June 16–17; his ashes are buried in Rottingdean churchyard. Memorial Service held at Westminster Abbey.

1898–9 Retrospective exhibition at the New Gallery.

Notes

Introduction

1 Henry James, cited in Frances Spalding, *Magnificent Dreams: Burne-Jones and the Late Victorians*, Oxford and New York 1978, p.16.

2 GB-J (Georgiana Burne-Jones), *Memorials of Edward Burne-Jones*, 2 vols., New York 1971, vol.II, p.208.

3 J. Comyns Carr, 'Edward Burne-Jones', *Exhibition of the Works of Sir Edward Burne-Jones, Bart*, New Gallery, London 1898, p.22.

4 Debra N. Mancoff, *Burne-Jones*, San Francisco 1998, p.7.

5 Malcolm Bell, *Sir Edward Burne-Jones, Bart.: A Record and Review*, London and New York 1895, p.4.

6 W. Graham Robertson, *Time Was: The Reminiscences of W. Graham Robertson*, London 1945, p.82.

7 *Memorials*, vol.II, p.8.

8 Cited in Penelope Fitzgerald, *Edward Burne-Jones*, London 1975, p.19.

9 Cited ibid., p.19.

10 Julia Cartwright, 'Sir Edward Burne-Jones, Bart: His Life and Work', *Art Annual*, Christmas 1894, pp.1–2.

11 J.E. Phythian, *Burne-Jones*, London 1908, p.64.

12 Robert de la Sizeranne, *Contemporary English Art*, trans. H.M. Poynter, Westminster 1898, pp.239–40.

13 Fortunée de Lisle, *Burne-Jones*, London [1904], 2nd ed. 1906, p.4.

14 Frances Horner, *Time Remembered*, London 1933, p.120.

Chapter 1: The Nicest Young Fellow in Dreamland

1 Cited in Fitzgerald, *Edward Burne-Jones*, London 1975, p.25.

2 Cited in Stephen Wildman and John Christian, *Edward Burne-Jones: Victorian Artist-Dreamer*, exh. cat., Metropolitan Museum of Art, New York 1998, p.45.

3 Fiona MacCarthy, *William Morris: A Life for Our Times*, London 1994, p.52.

4 *Memorials*, vol.I, p.110.

5 *Edward Burne-Jones: Victorian Artist-Dreamer*, New York 1998, p.50.

6 *Memorials*, vol.I, p.117 (said of Malory).

7 Cited in Mancoff, *Burne-Jones*, San Francisco 1998, p.13.

8 *Memorials*, vol.I, p.127.

9 Cited in Mancoff, *Burne-Jones*, San Francisco 1998, p.20.

10 Ibid., p.25.

11 *The Works of John Ruskin*, ed. E.T. Cook and Alexander Wedderburn, 39 vols., London 1903–12, vol.III, p.624.

12 Cited in *Edward Burne-Jones: Victorian Artist-Dreamer*, New York 1998, p.59.

13 Ibid., p.57.

14 Rossetti, cited in Aylmer Vallance, 'The Decorative Art of Sir Edward Burne-Jones', *Art Annual*, Easter 1900, p.2.

15 See *Edward Burne-Jones: Victorian Artist-Dreamer*, New York 1998, pp.66–70.

16 Cited ibid., p.72.

17 Cited in Fitzgerald, *Edward Burne-Jones*, London 1975, p.80.

18 *Burne-Jones Talking: His Conversations 1895–1898. Preserved by his Studio Assistant Thomas Rooke*, ed. Mary Lago, London 1981, p.167.

19 Cited in Fitzgerald, *Edward Burne-Jones*, London 1975, p.93.

20 Ibid., p.93.

Chapter 2: Exile and Achievement

1 Cited in *Edward Burne-Jones: Victorian Artist-Dreamer*, New York 1998, p.138.

2 J.L. Roget, *A History of the Old Water-Colour Society*, 2 vols., London 1891, vol.II, p.117.

3 *Memorials*, vol.II, p.12.

4 Rossetti, *Letters*, 2 vols., 1965, vol.II, p.685.

5 *Memorials*, vol.II, pp.12, 13.

6 Ibid., p.13.

7 Ibid., p.12.

8 Ibid., p.23.

9 Ibid., p.26.

10 Cited in Mancoff, *Burne-Jones*, San Francisco 1998, p.62.

11 Cited in *Edward Burne-Jones: Victorian Artist-Dreamer*, New York 1998, p.248.

12 Cited in Fitzgerald, *Edward Burne-Jones*, London 1975, p.245.

13 *Edward Burne-Jones: Victorian Artist-Dreamer*, New York 1998, p.159.

14 Cited ibid., p.159.

Chapter 3: The Grosvenor Gallery and Fame

1 Cited in Robyn Asleson, *Albert Moore*, London 2000, p.144.

2 Cited in Elizabeth Prettejohn (ed.), *After the Pre-Raphaelites: Art and Aestheticism in Victorian England*, Manchester 1999, p.3.

3 *New York Tribune*, 7 June 1878.

4 B. Bryant, 'G.F. Watts at the Grosvenor Gallery', in Casteras and Denney (eds.), *The Grosvenor Gallery*, p.116.

5 W. Graham Robertson, *Time Was: The Reminiscences of W. Graham Robertson*, London 1945, p.47.

6 Cited in Fitzgerald, *Edward Burne-Jones*, London 1975, p.167.

7 Ibid., p.167.

8 *Memorials*, vol.II, p.75.

9 Henry James, *The Painter's Eye: Notes and Essays on the Pictorial Arts*, ed. John L. Sweeney, London 1956, p.47.

10 *Edward Burne-Jones: Victorian Artist-Dreamer*, New York 1998, p.192.

11 Christine Poulson, *The Quest for the Grail: Arthurian Legend in British Art 1840–1920*, Manchester 1999, pp.148–9.

12 *Memorials*, vol.II, p.261.

13 William Waters, *Sir Edward Coley Burne-Jones, Bart, 1833–1898, Laus Veneris*, Newcastle upon Tyne 1975, n.p.

14 Henry James, *The Painter's Eye*, London 1956, p.164.

15 Sizeranne, Robert de la, *Contemporary English Art*, trans. H.M. Poynter, Westminster 1898, p.287.

16 T.M. Rooke, 'Note on Burne-Jones's Medium', *Burne-Jones*, Mappin Art Gallery, Sheffield 1971, p.8.

17 *Memorials*, vol.I, p.261.

18 F.G. Stephens, *The Athenaeum*, 18 May 1878, p.642.

19 Algernon Charles Swinburne, 'Laus Veneris', *Poems and Ballads*, 1st series, London [1866], 1927 ed., p.26.

20 Cited in *Edward Burne-Jones: Victorian Artist-Dreamer*, New York 1998, p.222.

21 Frederick Wedmore, 'Some Tendencies in Recent Painting', *Temple Bar*, vol.53, July 1878, p.339.

22 *Art Journal*, June 1884, p.189.

23 Cited in *Edward Burne-Jones: Victorian Artist-Dreamer*, New York 1998, p.254.

24 *Memorials*, vol.II, p.135.

25 Cited in *Edward Burne-Jones: Victorian Artist-Dreamer*, New York 1998, p.254.

26 Fitzgerald, *Edward Burne-Jones*, London 1975, p.143.

27 Cited ibid., p.192.

Chapter 4: Avalon

1 Fitzgerald, *Edward Burne-Jones*, London 1975, p.242.

2 Frances Horner, *Time Remembered*, London 1933, p.118.

3 *Memorials*, vol.II, p.337.

4 Ibid., p.337.

5 *Burne-Jones Talking*, London 1981, p.84.

6 *Edward Burne-Jones: Victorian Artist-Dreamer*, New York 1998, pp.322–3.

7 *Burne-Jones Talking*, London 1981, p.84.

8 Ibid., p.85.

9 *Edward Burne-Jones: Victorian Artist-Dreamer*, New York 1998, p.327.

10 Cited in Fitzgerald, *Edward Burne-Jones*, London 1975, p.276.

11 Cited in Mancoff, *Burne-Jones*, San Francisco 1998, p.119.

12 Martin Harrison and Bill Waters, *Burne-Jones*, London 1973, p.168.

13 *Burne-Jones Talking*, London 1981, p.110.

14 Burne-Jones, cited in Mancoff, *Burne-Jones*, San Francisco 1998, p.115.

15 Cited in *Edward Burne-Jones: Victorian Artist-Dreamer*, p.306.

16 *Burne-Jones Talking*, London 1981, p.115.

17 Cited in Frances Spalding, *Magnificent Dreams: Burne-Jones and the Late Victorians*, Oxford and New York 1978, p.16.

18 *Burne-Jones Talking*, London 1981, p.178.

19 *Memorials*, vol.II, pp.187–8.

20 Ibid., pp.188–9.

21 Cited in *Edward Burne-Jones: Victorian Artist-Dreamer*, New York 1998. p.1.

22 Robin Ironside, 'Gustave Moreau and Burne-Jones', *Apollo*, March 1975, pp.173, 177.

Select Bibliography

Ash, Russell, *Sir Edward Burne-Jones*, New York 1973

Bell, Malcolm, *Edward Burne-Jones: A Record and Review*, London 1892

Burne-Jones, Edward, *Letters to Katie from Edward Burne-Jones*, London 1988

Burne-Jones, Georgiana [GB-J], *Memorials of Edward Burne-Jones* [1904], 2 vols in 1, Freeport, New York 1971

Christian, John, *The Last Romantics: The Romantic Tradition in British Art: Burne-Jones to Stanley Spencer*, London 1989

Fitzgerald, Penelope, *Edward Burne-Jones: A Biography*, London 1975

Harrison, Martin and Bill Waters, *Burne-Jones*, London 1973

Ironside, Robin, 'Gustave Moreau and Burne-Jones', *Apollo*, March 1975, pp.173–82 [originally published in 1940]

Lago, Mary (ed.), *Burne-Jones Talking: His Conversations 1895–1898. Preserved by his Studio Assistant Thomas Rooke*, London 1981

Mancoff, Debra N., *Burne-Jones*, San Francisco 1998

Robinson, Duncan, *William Morris, Edward Burne-Jones and the Kelmscott Chaucer*, London 1982

Spalding, Frances, *Magnificent Dreams: Burne-Jones and the Late Victorians*, Oxford and New York 1978

Thirkell, Angela, *Three Houses*, London 1986

Wildman, Stephen and John Christian, *Edward Burne-Jones: Victorian Artist-Dreamer*, exh. cat., Metropolitan Museum of Art, New York,1998

Wood, T. Martin, *The Drawings of Sir . Burne-Jones*, London 1906

Photographic Credits

Index